THE BETTER DIGITAL PHOTOGRAPHY GUIDE TO

Landscapes, Seas and Skies

D1300628

Argentum

First published in Great Britain 2006 by Argentum, an imprint of
Aurum Press Ltd, 25 Bedford Avenue, London WC1B 3AT
www.aurumpress.co.uk

A catalogue record for this book is available from the British Library.

ISBN 1 902538 41 2

1 2 3 4 5 6 7 8 9 10
2006 2007 2008 2009 2010 2011

Designed by Toby Matthews, toby.matthews@ntlworld.com
Packaged & Concept by Angie Patchell
at emergingartbook producers, www.emergingart.co.uk

Printed in Singapore

THE BETTER DIGITAL PHOTOGRAPHY GUIDE TO

Landscapes Seas and Skies

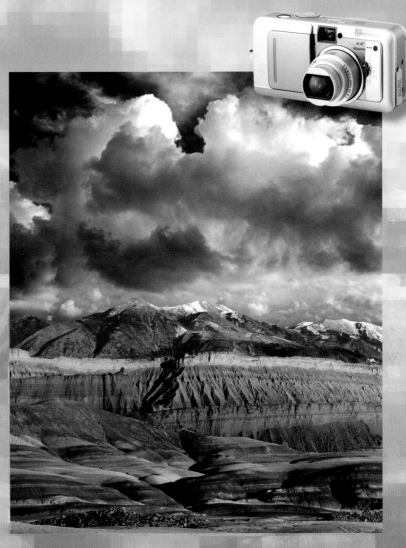

Michael Busselle

THE BETTER DIGITAL PHOTOGRAPHY GUIDE TO

Landscapes Seas and Skies

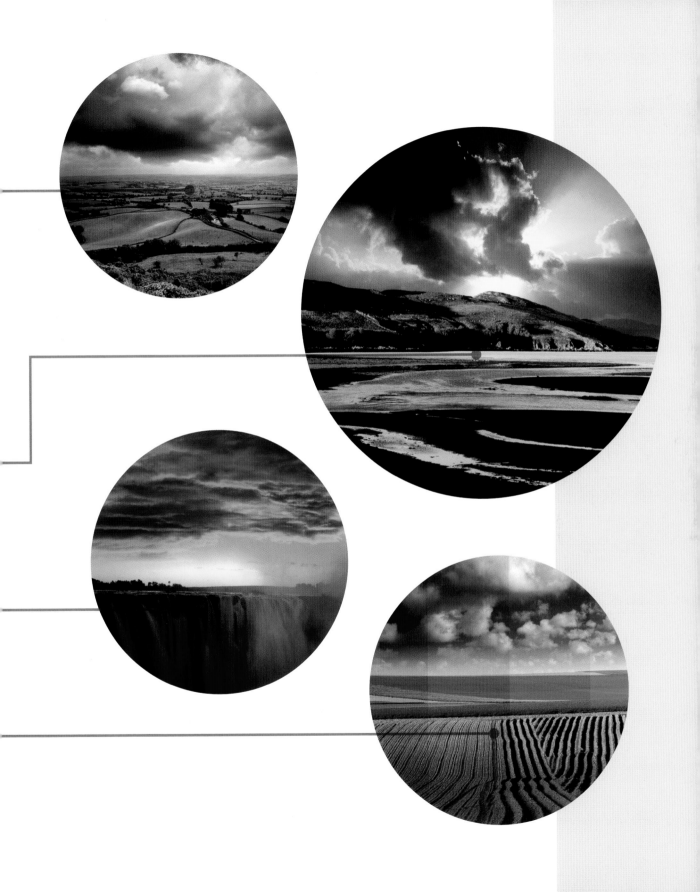

Introduction

The landscape has been a source of inspiration for countless creative people as well as simply being something which is there for all to experience and enjoy. There is something spiritually uplifting about seeing the beauty which the forces of nature have created and for a photographer the effect is amplified when it can be used as a means of expressing the feelings the experience evokes.

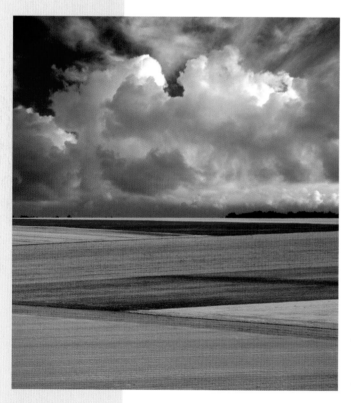

The aim of this book is to show something of the rich variety of subject matter which our planet possesses and the ways in which it can be used to produce striking images. While the more spectacular vistas quite understandably attract the greatest attention it's important to appreciate that beauty is very much in the eye of the beholder when it comes to photography and potentially photogenic subjects are all around us.

A perceptive eye for shape, texture, colour and light is the key to producing outstanding landscape images and the aim of this book is to illustrate and explain how these vital, visual skills can be developed together with the process of composing and recording what is seen in the most effective way.

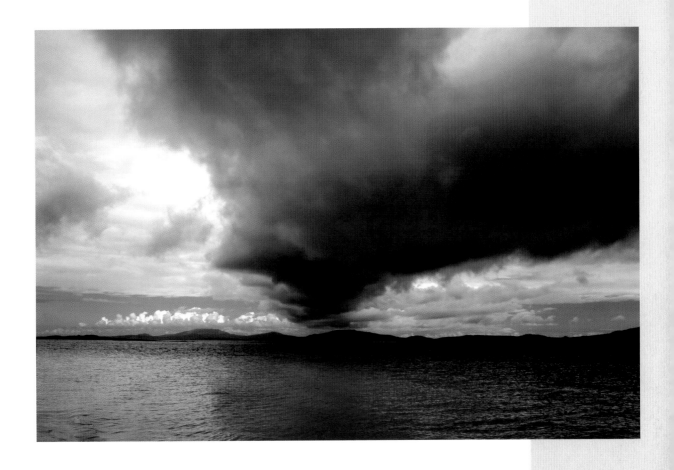

As a professional photographer for more than fifty years I've worked in many fields of the medium but photographing the landscape has always been my greatest passion. During this period I've used a huge variety of cameras and processes but none excites as much as those available today. Digital capture and image control have opened my eyes to new ways of seeing the landscape and have introduced me to virtually unlimited creative possibilities for controlling and presenting the final photograph.

"A perceptive eye for shape, texture, colour and light is the key to producing outstanding landscape images"

19 steps to capturing images

the classic view

One of the most frequently taken landscape pictures is of a lovely view, as this is the kind of subject that it's hard to resist snapping. The desire to have a visual memento of a beautiful place is often the main reason for photographing it.

Dead Horse Point

The first step towards producing an eye-catching photograph of a classic view is, of course, to have the right viewpoint. There are a number of viewpoints which have become almost legendary among landscape photographers, with many of them having been photographed initially by people like Ansel Adams and Edward Weston. It's not uncommon for enthusiasts to plan their photographic itineraries around some of these places. However, this approach invites disappointment, as it's very unlikely that similar conditions to the iconic image will be found on a casual visit.

This shot of Dead Horse Point in the Canyonlands National Park in Utah was taken from a well-known,

well signposted and much-used viewpoint. Little else was needed to capture it other than planning to arrive in the late afternoon on a day when the sunlight was clear and undiffused. The picture was taken using a wide-angle lens and a polarising filter to increase the colour saturation of the rocks.

I'd seen a stunning photograph of the same scene in the gallery of Tom Till in the nearby town of Moab and, in comparison, my effort seemed very inferior. But in the notes about his image he mentioned he'd visited the viewpoint more than 100 times before capturing his shot.

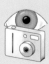

When your motive is primarily to produce a striking image, landscape pictures are among the most difficult subjects to photograph. When distant details are an important element of a scene, then the conditions need to be as close to ideal as possible because atmospheric haze and diffused light will detract significantly from the clarity of the image. The best landscape photographs are usually the result of good luck in being at the right place at the right time, or of the willingness to keep returning to the same location until the conditions are right.

> **"The scene appealed to me because the acutely-angled sunlight was creating some beautifully graduated contours in the gently rolling landscape"**

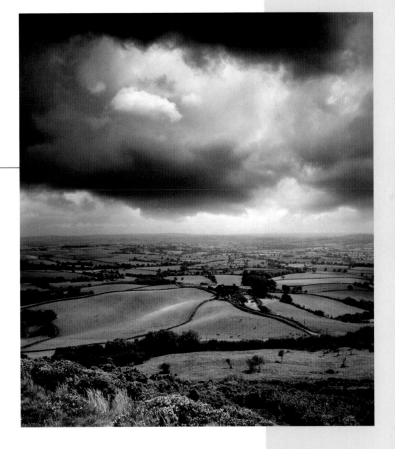

Hill Fort

This landscape picture was entirely unplanned, as I'd been commissioned to take some photographs to illustrate a book that involved visiting an iron-age hill fort. Having climbed the hill to the site I was surprised and delighted to see a sweeping view of the surrounding countryside. The landscape was lit in a very pleasing way by the low sun of a late spring afternoon and the atmosphere was clear enough to see far into the distance. The scene appealed to me because the acutely angled sunlight was creating some beautifully graduated contours in the gently rolling landscape, which was an attractive shade of green. I used a wide-angle lens and chose a viewpoint which allowed me to frame a little of the gorse in the foreground to heighten the sense of depth and distance.

The only disappointment in the scene was a rather featureless grey sky. I contemplated cropping it out, but this would have eliminated the horizon and spoiled the far-reaching effect. To overcome the problem I decided to add some sky from another image (which had a similar, but darker tone) in the way described on pages 64–65. I included a large area of the new sky as I liked the dramatic effect of the stormy clouds and felt that it created a better balance with the foreground.

featuring the sky

The sky needs to be considered carefully in landscape photography as it can either make a very positive contribution to the impact of an image or seriously detract from it. An empty, white sky is best avoided in most circumstances as it can have a very negative effect on the image by drawing attention away from the landscape and, in many cases, weakening the colour and contrast of the remainder of the image.

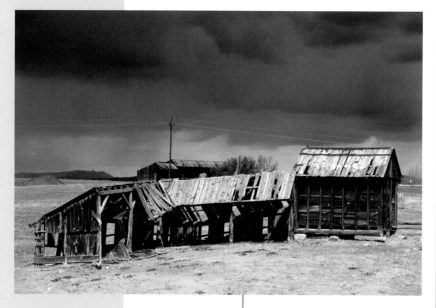

Colorado Farm

I spotted this decaying farmhouse while driving along a quiet country road in Colorado. I was attracted by its tumbledown state and by the arrangement of the buildings, which I thought were nicely grouped. I also liked the telegraph pole and cable. In normal circumstances, I would probably have thought of these as a distraction, but here they seemed to contribute to the mood of the scene. But it was the sky that clinched it for me, and I doubt I would have shot the picture had it been blue. I had to hurry as the gap in the clouds, which was allowing a little weak sunlight to create a highlight on the roofs, was rapidly closing.

Atlas Clouds

The road over the Atlas Mountains to the south of Marrakesh provides one of the most thrilling drives you can have, but it's not particularly rich in opportunities for photographs because it is largely rather featureless. One of the few noticeable features is the reddish brown rock, which, in many places, has these curious striations. I thought there was some potential in the rock striations but could not find any other features with which to make a composition. As I approached the summit of the pass the sky became a deep, rich blue and some small, nicely shaped clouds began to bubble up. It occurred to me that they could provide the other element the image needed. I then found a viewpoint where I was able to include an interesting section of the mountain together with the approaching clouds. I used a polarising filter to make the clouds stand out in strong relief. This had the effect of making the blue sky at the top of the frame darker than I would have liked, so I used the graduated mask in Photoshop to make it a bit lighter.

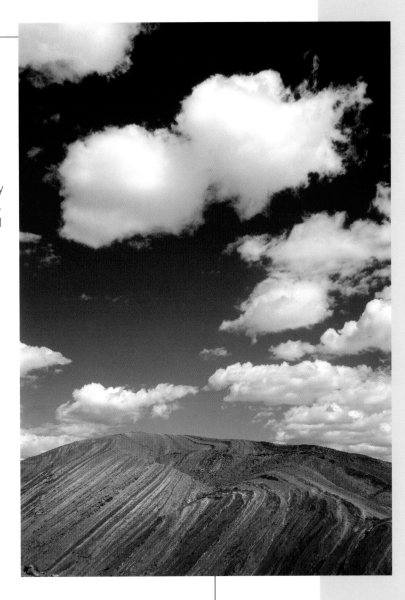

It is often possible to simply frame the image in a way that excludes any blank sky, and this can improve both the quality and impact of the landscape. A plain blue sky does not have the same negative effect as a white sky but it rarely adds much to the image. As a general rule, it's best to frame the image to include as little sky as possible, or even to exclude it altogether. But when the sky has interesting clouds including some of it can often produce more powerful and atmospheric photographs.

"When the sky has interesting clouds it can often be used to produce more atmospheric photographs"

looking for patterns

The key to all creative photography lies in developing the ability to see beyond the subject itself, and to recognize the essential visual elements that will give an image the structure and impact it needs to succeed. One of these visual elements is the impression of a pattern, created by the repetition of lines or shapes in a scene.

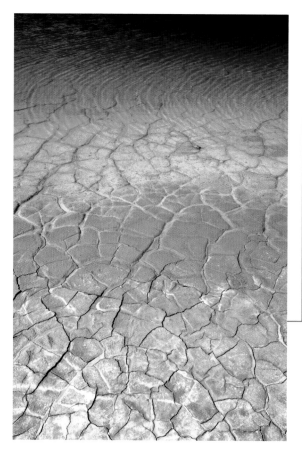

Cracked Earth

Nature has a wonderful knack of creating patterns and once you start to look you can see them everywhere. This shot was taken at some old mine workings. The earth had dried up forming a network of cracks and recent rain had created large puddles that had been coloured by mineral deposits in the soil. I tried some shots of the cracked area alone but, although initially quite striking, there was not enough variation in tone or colour to maintain interest. To overcome this problem I looked for a viewpoint where there were some well-formed cracks close to a puddle. I then shot from as high up as my tripod would go, looking almost directly down and using a wide-angle lens. I used a polarising filter to reduce the reflections on the rippled water and to make the colour more saturated.

Subjects like landscapes often need something to give the image some cohesion and to draw the viewer's eye into the picture. A pattern can do this very effectively. It does not need to be a pattern in a literal sense, just a suggestion of a repeated shape is often enough to create a focus of attention and give the image a balanced and harmonious quality.

La Mancha

Whenever you are in flat countryside even the smallest hill seems to provide a bird's eye view. Spain's La Mancha region is like a billiard table in places; the hills are dotted with windmills and are a picturesque sight. One of the most visited hills, complete with a castle, lies above the small village of Consuegra. The view from here is also one of the best in the region, and I was lucky enough to be there on a day when the sunlight was undiffused and the atmosphere clear. There's an almost 360 degree view from here and I chose a viewpoint which enabled me to use a small track winding away into the distance as a focus of attention, framing the image so that it was to one side of the centre.

The sky was a deep, clear blue, but not very interesting, and I'd framed the image to include only a small area of it. Looking at the photograph I felt it was a little unbalanced with too much weight being given to the landscape. To correct this I added a rather larger area of sky with some nice clouds using the method described on pages 64–65.

"Nature has a wonderful knack of creating patterns and once you start to look you can see them everywhere"

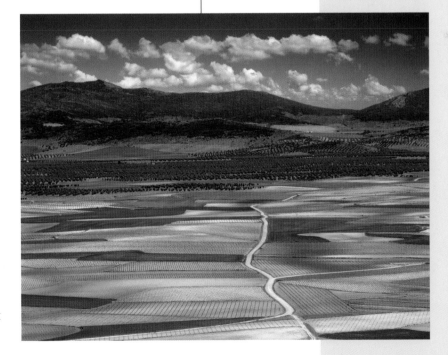

using texture

The photographic process has an almost uncanny ability to reproduce texture. When successfully captured in an image, texture can be one of the most effective qualities in a subject.

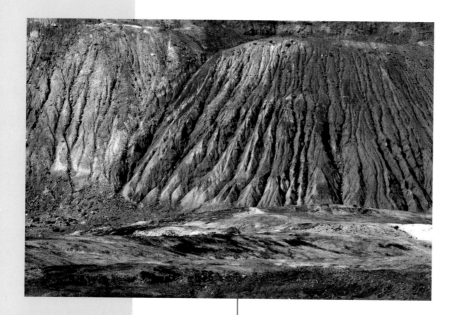

"The way a subject is lit is crucial to the outcome of images"

Mine Workings

The mine workings of Rio Tinto in southern Spain have created a quite astonishing landscape and, by all normal standards, made a scar on the countryside. But I found the sheer scale and rich colour of the mineral deposits irresistible as a subject. The day on which this shot was taken was sunny but with enough light cloud in the sky for it to be significantly diffused. Most distant landscape subjects would have probably been rather too soft to create a strong textural effect. But the deeply indented quality of the spoil heap, with the ridges formed by water erosion, provided enough inherent texture in the scene to produce the effect I wanted. I used a long-focus lens to isolate the most impressive area of the terrain and framed the image so that the red tinted earth occupied about two thirds of the image.

Gara Rock

I think bracken can be a very negative element in a scene for the landscape photographer. During the summer it's rather dense, bland green tends to dominate huge areas of the countryside while in the winter bracken appears a dull dead brown. Even in springtime the fresh green growth is often not enough to cover the dead bracken. But there is a period in late autumn and early winter when bracken turns to a wonderful burnished hue of rich red-brown that I find very appealing. This picture was taken in South Devon in the late afternoon when the sun was very low in the sky and skating across the landscape creating a bold texture. I used a long-focus lens to frame an area of the scene where there was a good balance between the bracken covered hillside and the smoother meadows.

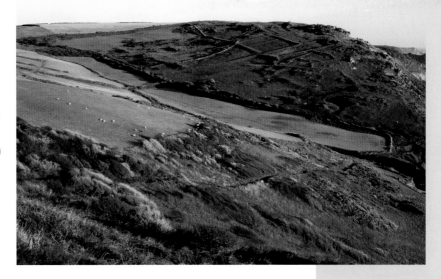

The Key To

The key to exploiting the textural quality of a subject is in judging the quality of the light and the effect is has on the surface it's illuminating. A coarse, deeply indented texture needs to be lit with a more diffused and less acutely angled light than a finer, more subtle texture.

From the weathered skin quality of a character portrait or the fur of an animal, to the subtlety of rippled water or the differences in surfaces in a basket of mixed fruits, a photograph can seem extremely convincing and tactile. Texture can also be a powerful ingredient in landscape photography, both in close up images and when a distant viewpoint creates a textural effect from details such as furrowed fields, trees and crops. The way a subject is lit is crucial to the outcome of images like these. Acutely angled sunlight is often the most effective lighting for more distant scenes, which is why many landscape photographers favour the light early or late in the day when the sun is low in the sky

photographing trees

I must own up to being just a little obsessive when it comes to photographing trees, I can't resist a well-shaped and nicely lit tree when I see one in a photogenic situation, and I'm sure I'm not alone.

Birches

This shot was taken during an autumnal trip to Scotland as I drove along the shores of Loch Etive. I particularly like birch trees, partly for their light coloured, textured bark, but also for the tall, elegant shapes they develop. There were many fine trees to choose from in this view. The difficulty, as always, was to find a way of separating some of them from the background. This small group of trees was on a piece of land that jutted out into the loch and I was able to find a viewpoint where they were set mainly against the sky. I was lucky because there were some quite dark clouds adding an element of mood. I thought this was better than a blue sky, which could have produced a too-pretty, postcard type picture. My viewpoint was restricted and quite close to the trees so I needed to use a very wide-angle lens, with the camera tilted upwards, in order to include enough of the tops of the trees.

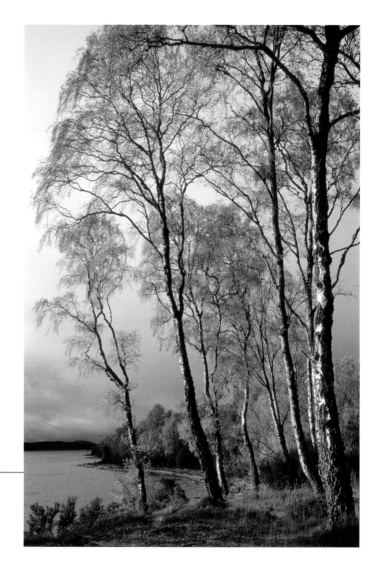

Photographs depend partly for their success upon contrasts, not only tonal and colour contrasts but also contrasting shapes. In landscape photography horizontal lines and shapes tend to dominate the image and when a vertical shape, such as a tree, is introduced the effect is invariably eye-catching. The most important factor in producing a strong image of a tree is that it needs to be clearly defined and isolated in some way from its surroundings. Winter is a satisfying time of year to photograph trees because very often the structure of the tree and the shapes created by its branches are more interesting than when they are masked by foliage. When shooting trees in a forest or plantation the pattern effect can often be used in a striking way. Trees also have enormous potential as close-up subjects.

"The most important factor in producing a strong image of a tree is that it needs to be clearly defined and isolated"

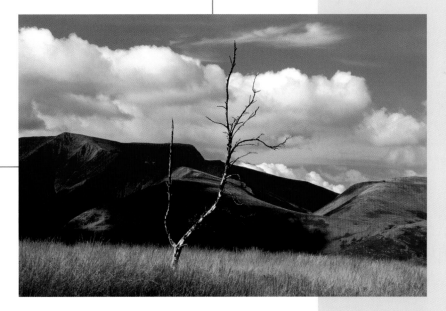

Dead Tree

I'm particularly fond of single isolated trees. There's something about them that evokes a rather lonely and meditative mood and this one seemed especially forlorn. I was shooting pictures in Cumbria with my son Jules. He had opted for a very close viewpoint using a wide-angle lens and practically filling the frame with the tree. I, however, wanted to accentuate the lonely mood and decided to shoot from a much more distant viewpoint using a long-focus lens. This produced some compression of the image's perspective and resulted in the tree—although quite well separated—being shown in closer juxtaposition to the distant mountains and cloudbank than I would have liked. I used a polarising filter to make the clouds stand out more boldly from the blue sky.

nature in close-up

Like myself, I imagine many landscape photographers develop a sort of distant vision with a tendency to constantly scan the countryside looking for potential subjects. I find it quite hard to switch off from this mode and, even when travelling without a camera, I subconsciously look for photogenic scenes. This often has the effect of making you blind to the possibilities of subjects, which are much closer to you.

Fungi

I shot this picture on a rather dark, dank autumnal day in some woodland near my home. I'd gone there to try out a new piece of equipment and had hoped that the autumn colour might provide me with some good opportunities. Unfortunately the full glory of the autumn colour had not yet developed. Also the light was very soft, creating a rather flat and lifeless look, which made the chance of taking a worthwhile picture seem unlikely. But this display of fungi growing on a decaying log caught my eye, mainly because of the striking pattern that the edges of the fungi had created. The soft light of the overcast day suited this subject very well. I used a macro lens to enable me to shoot a small area of the tree in order to maximize the impact of the shape and texture of the fungus. The damp conditions had allowed some water droplets to form and, in order to make these sparkle more brightly, I used fill in flash to supplement the daylight.

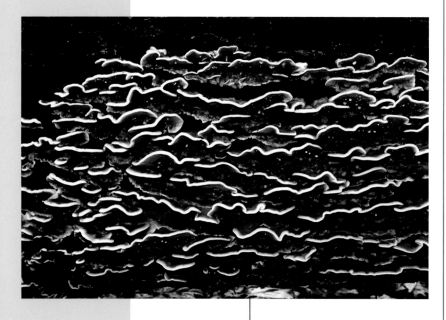

There is such a rich variety of colours, textures, shapes and patterns within even the most ordinary natural forms that there never need be an occasion when you are unable to find a worthwhile subject. It is simply a question of focusing your attention on things at a closer range.

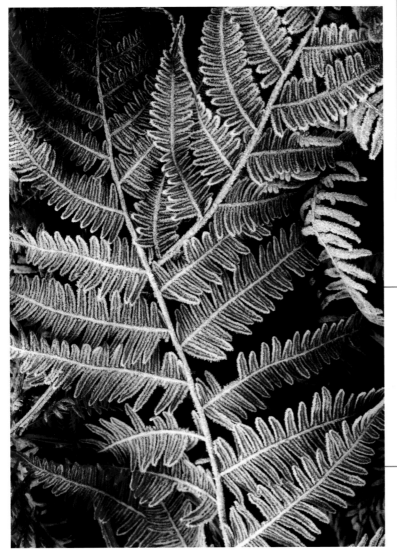

Frosted Fern

This image was captured at the same woodland location as the fungi. The photograph was taken early on a winter's morning after a hard frost had covered much of the wood in ice crystals. The sun was beginning to reach into the wood when I arrived and areas of the frost had already begun to melt away. This fern leaf attracted my eye because of its attractive shape and because it was quite well separated from its surroundings. I also liked the fact that the warm light of the sun was mixing with the blue quality of the shaded areas. This had created an element of colour contrast along with the difference between the parts of the fern still covered with frost, and the redder tones of where it had begun to thaw. I used a long focus lens in conjunction with an extension ring in order to focus on the most effective section of the fern, and I framed the image so that the main stem of the leaf formed a Y shape.

"I liked the fact that the warm light of the sun was mixing with the blue quality of the shaded areas"

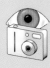

the abstract approach

One of the great strengths of the photographic process lies in its ability to create a very lifelike representation of the subject, a vital aspect of many of the medium's applications. However, for more personal and expressive work this lifelike quality can be a drawback, because the purpose of such images is often to produce a less literal and more interpretive rendition of a subject.

Maize and Sunflowers

The first step in making any photographic composition is to decide on the viewpoint and the way in which the image is framed. These decisions alone can go a long way towards deciding how identifiable the subject is and how true to reality the image appears. This image is in fact very factual, although it appears initially rather abstract, simply because of the way it is composed. A closer look reveals that the image is a small section of a field of ripening millet with an area of dead sunflowers behind it. But the tight framing, contrasting textures and rather geometric form created by the colour of the crops tend to make the eye dwell on these aspects of the image before considering the subject's identity.

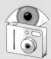

Image editing software provides numerous ways in which the realism of a photographic image can be modified, or even eliminated altogether. The software can create effects emulating watercolour paintings or pencil sketches, for instance, but there are also a number of ways in which an abstract quality can be created at the time of capturing the image.

"An abstract quality can be created at the time of capturing the image"

Sunset Surf

The sun had almost disappeared below the horizon when I took this photograph on a beach in southern Spain. The area of red sky was almost directly in front of the camera and was already losing much of its brightness, which helped to retain the colour in the sea created by the light from the still blue sky above. Shooting the picture earlier would have resulted in far too much contrast, with the highlights on the water being burned out, as the shaded areas of the sea were very dark. But the light level was already quite low and even with a higher ISO setting I was unable to use a shutter speed that would freeze the movement of the waves. I decided to make this a virtue and use a very slow shutter speed to create deliberate blur which would introduce a more abstract quality. I experimented with using a tripod-mounted camera and allowing all the blur to be created by the moving water. I also tried using a panning movement with a hand-held camera to follow the wave action. This latter technique produced the image I liked best and I made half a dozen or so attempts, varying both the shutter speed and the panning movement, before arriving at the result shown here.

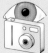

photographing water

Piedra Waterfall

I'm sure I'm not alone in liking waterfalls. There's a place I know in Spain called the Monastery of Piedra in the province of Aragon which is a waterfall lovers' paradise, with a deep circular valley at the bottom of which are several lakes. The steep sides of the valley are densely wooded and threaded by numerous waterfalls. Some trickle down between trees and bushes while others cascade out into space before crashing onto the valley floor. It was a sunny day but this particular waterfall was in deep shade and the light was soft producing a full but gently graduated range of tones. Direct sunlight would have created too much contrast with highlights being burnt out and shadows black. I chose a viewpoint that placed the secondary flow of water behind the main fall and framed the image to include some of the grass covered rock in the right foreground. I set an exposure of about one second to record the moving water as a soft, homogenous blur.

It may be something to do with our origins, but few people can resist the attraction of water. Whether it is a tiny rippling brook, a peaceful lake or a stormy sea there is something very emotive about this substance that makes up most of our planet. Water is particularly appealing to photographers because, as well as having a strong emotive quality, its visual attributes are very tangible and extremely photogenic.

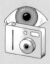

Sky Pond

I had a fleeting trip to the Isle of Skye a while ago with one day of glorious sunshine, one of torrential rain and one of heavily overcast skies. Oddly enough the overcast day provided the most interesting photographic opportunities, and this shot was taken when there were a few breaks in the cloud. The light was very soft, creating only very weak shadows; not the sort of lighting which would create enough contrast in a distant scene in normal circumstances. But the water here has given the image a much richer tonal range than it would have otherwise have had. The water has also created a foreground with an eye-catching quality where the shape of the reflected mountain and the texture created by the reeds has become the real focus of attention. I used a wide-angle lens to allow me to include both close foreground details and the distant mountain, and I set a small aperture to ensure the image was sharp from front to back.

Water has the very useful quality of being able to both reflect and transmit light and its form is infinitely variable. It also has the ability to create every tone from pure black to brilliant white, making it one of the most effective subjects for monochrome photography. Water can also display a full spectrum of colour, conjure a mood and help to create very atmospheric images.

> **"Water has the very useful quality of being able to both reflect and transmit light"**

the urban scene

Landscape photography implies open countryside and natural forms but cities and towns offer very similar opportunities of combining the magic of light with shapes, textures and colours, although constructed in this instance by man rather than nature.

Jain Temples

This extraordinary place is about as far from Las Vegas as you can get both culturally and visually. A city of temples near Palitana in the Indian state of Gujarat is a place of holy pilgrimage for those of the Jain faith. Nearly nine hundred temples have been built on a hilltop 2000 feet above sea level. Some of these pure marble buildings date back to the eleventh century and it is a breathtaking sight. My visit was timed to arrive as close as possible to sunrise when the lighting was very atmospheric but a little hazy. In some respects this was an advantage; if the sunlight had been much harsher the contrast of the scene would have been unmanageably high. I used a wide-angle lens to include a wide expanse of the city and framed the image to exclude some unattractive buildings, which threatened to encroach into the foreground. This has resulted in the image being more tightly cropped than I would have liked. The atmospheric haze resulted in the sky being rather disappointing, so I added another from my 'cloud bank' using the method described on pages 64–65.

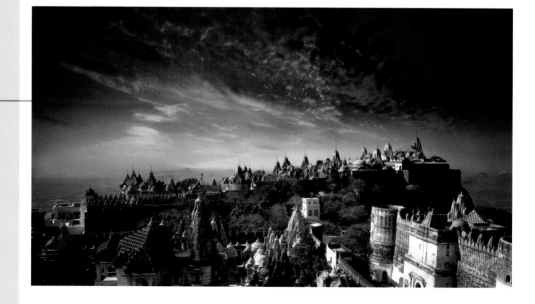

Las Vegas

My first visit to Las Vegas was preceded by a few days in Death Valley in California and it's hard to express the impact the contrast between these two locations had on me. I really liked and enjoyed Las Vegas and it made a refreshing change from the awe-inspiring but bleak and rather predictable appearance of Death Valley. One major difference between urban and rural landscapes is that there tends to be much greater freedom and wider choice of viewpoints with the latter, although Las Vegas provides much more opportunity than many cities I've visited. A number of walkways cross the main thoroughfare from which the photographer is offered an impressive variety of views of the city and its extraordinary hotels. This picture was shot from one of these bridges. I chose the late afternoon for my first sortie when the presence of sunlight was still noticeable but most of the buildings were not in direct sunlight. With such a range of colours, shapes and patterns I felt that a soft light with a lack of dense shadow areas was vital. I used a long-focus lens to isolate a relatively small area of the scene, as a wider view would have overwhelmed the eye. It would then have been almost impossible to produce a cohesive composition.

Although the subject matter is very different the same disciplines are necessary; thoughtful choice of viewpoint, careful composition and a feeling for the quality and effect of light. Buildings provide a change of pace from Nature and the opportunity to see things in a rather different way. Urban photography can be a useful and instructional experience for the photographer who is more accustomed to seeking his or her pictures in the countryside. The more angular forms of the urban scene and the variety of colours, textures and patterns can trigger a fresh outlook as well as adding variety and breadth to a portfolio of work.

> **"Buildings provide a change of pace from Nature and the opportunity to see things in a rather different way"**

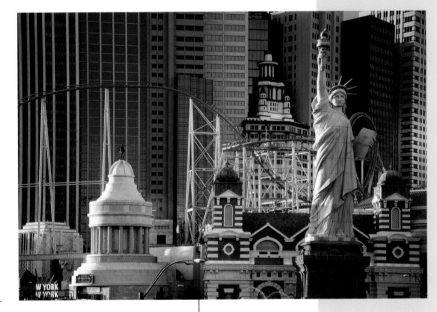

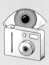

coastlines

The places where the land meets the sea have always held a fascination for me and I'm sure for many other people too. I still get a tingle when I first sense that the sea is near. It's not just the appearance of the countryside, there also is something about the atmosphere, maybe it's the smell of ozone.

Trentishoe

I find the North Devon coastline especially lovely and also very varied. Within a relatively small area it goes from precipitous cliffs and rocky coves to gentle down lands and vast sandy beaches backed by dunes. This shot was taken near the hamlet of Trentishoe looking towards Highveer Point on an early autumn day when there was quite a lot of cloud and some atmospheric haze. This has resulted in a very soft, diffused light and a scene with fairly low contrast, but I felt this enhanced the gentle, peaceful atmosphere of the scene. A lack of image contrast is not the problem it once was when limited to what film could produce as it can readily be increased at the image editing stage. I chose a viewpoint and framed the image to include some of the bracken and the bush in the foreground in order to enhance the impression of depth and distance and also to add a little contrast to the image.

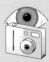

The transition of earth to water happens in a variety of ways and each offers its own visual qualities and different pictorial possibilities. From sand dunes and pine forests to towering cliffs and salt marshes, time spent on the edge of the land is almost guaranteed to provide the opportunity for interesting photographs. The presence of other features, such as harbours, breakwaters and piers, can add interest to a composition.

"The presence of features such as harbours, breakwaters and piers, can add interest to a composition"

Cancale

The small town of Cancale in Brittany is renowned for its oysters, which are reared in beds built among the rocks on the beach in front of the town. The sea here recedes a vast distance at low tide allowing the tractors to go out and harvest the shell fish, which can be bought and eaten on the quayside, the freshest you'll ever taste. On this occasion there had been a storm with dense, dark clouds and lashing rain but small breaks in the clouds were beginning to form, allowing shafts of sunlight to stream onto the beach. In combination with the dark sky the effect was quite dramatic. I looked for a viewpoint with some haste as such conditions seldom last very long. I framed the image to include a large area of the sky, in a way that placed the tractor close to the bottom edge, but about a third of the way into the image.

man-made landscapes

I have a liking for what you might call unspoiled countryside, places which have not yet been violated by human kind. Given half a chance, I would like to go to almost any of the planet's remaining wilderness areas. This is in the full knowledge that they're fiendishly difficult to photograph.

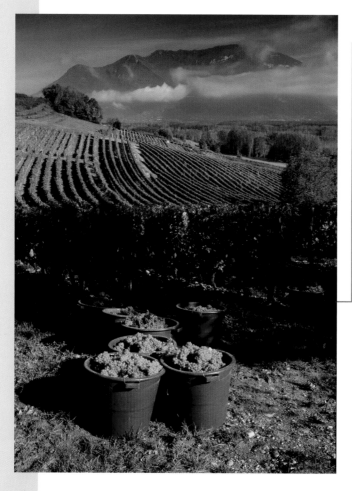

Bugey Vineyards

This shot was taken in the Bugey region of France, between Burgundy and the Alps, in the early autumn when the farmers had just started to harvest the grapes. It was fairly early in the morning, and the light was still at a low angle with some mist remaining around the distant mountain, when I spotted these baskets of grapes by the roadside. The acutely angled light had created a rich texture on the vine rows and I was lucky that the grapes had been left in the sun rather than in the shaded spot further back. I used a wide-angle lens from a fairly close viewpoint to give the grapes some prominence and framed the image so that the baskets and mountaintop were both close to the borders of the image. I set a small aperture to ensure enough depth of field and used a polarising filter to make the sky a richer and darker blue.

I have to confess that where humankind has made his or her mark it becomes easier to make photographs. I suppose the ultimate man-made landscape is a garden but even just the presence of a building, wall, track or cultivated field can make it easier to create a pleasing composition with a focus of interest. We tend to impose a sense of order and organization when we take over the landscape, creating shapes, patterns and textures which would not otherwise be there.

"Where humankind has made his or her mark it becomes easier to make photographs"

Dry Stone Wall

I'm a great admirer of the artist Andy Goldsworthy who constructs objects from natural materials within the landscape. Many of these natural sculptures are transient, only existing for a short space of time. I suppose in a way this image was inspired by him, as it is effectively a sort of still life, but one which has been there for a good many years and will probably remain for many more. Many regions of England are patterned by dry stonewalls so why should this one in particular appeal to me? The wall itself was very pleasing to my eye because of the mix of coloured stone and the way in which the brown stone was distributed. The lighting was near perfect, sharp and angled enough to reveal strong texture, but not so much as to create too much contrast. I also liked the way the green, curved hill rose up behind the wall and how the fluffy, white clouds were strung along its edge leaving plain blue sky above. This had the effect of dividing the image into horizontal bands of different colours and textures.

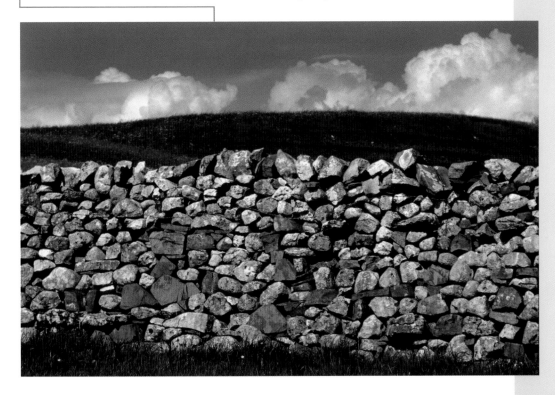

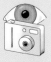

seascapes

Like any large expanse of water the sea has many moods and both its character and appearance can change with breathtaking swiftness. This is not only because of the movement of the water but also because of the sky that illuminates it and it is this interplay which provides such a fascinating subject.

Surf Beach

I've visited this beach frequently on the Costa del Sol over a long period and at different times of the year. I've seen and photographed it in so many different moods, it's sometimes been hard to believe that it is the same beach. On this occasion I was attracted by the simplicity of the image, which was made up of two triangles and a rectangle. This was underlined by the almost monochromatic quality created by the very soft lighting. It was early morning and the cloud had not yet cleared making the sea seem quite grey. An hour later the sea became a deep blue to match the sky. The sand on this beach is volcanic in origin and quite dark in colour, which has helped to create the near black tone and the striking contrast with the sea and sky.

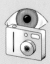

On a still day with a deep blue sky the sea can look idyllic, whether it is the North Atlantic, the Mediterranean or the Caribbean, but when clouds form and the wind whips up the waves a peaceful, welcoming expanse of water can suddenly become quite sinister and very threatening.

Indian Ocean

The Maldives are an extraordinary group of islands in the Indian Ocean, many little bigger than a decent sized garden. Each island is surrounded by a coral reef which protects their white sand beaches and creates a ring of translucent turquoise water around them. Here you can see the change in colour beyond the reef where the deep water of the ocean is an inky indigo. It was the blocks of colour which interested me here and the strange shape in the water. I chose a viewpoint which made the shape appear to be coming towards me and framed it using a wide-angle lens to include as much as possible. I used a polarising filter to enhance the colour of the water and to make it more translucent.

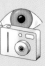

an eye for colour

Most contemporary photographs are shot in colour and these days the colour content of the subject could be considered the most important element of all as it can very easily override all the other qualities. However, many people who are very critical of colours when decorating a room or choosing clothes will take photographs without even noticing which colours are present in a scene.

Red Harrow

I spotted this red harrow parked in a field in north Devon. It would have stirred my interest anyway but the striking contrast between the red harrow, bright blue sky and green field made it a must have shot. Using a long focus lens to enlarge the area of interest I framed the image so that the harrow was placed towards the corner of the frame, in a way that included the most important clouds with a little space around them.

I wanted to emphasize the rather strange and theatrical feeling of the scene and I decided to use the hue and saturation control to create a slightly unreal colour quality. For good measure I also decided to make the image a little grainy by using Filter>Noise Add Noise.

The most striking colour images will invariably be those where the colour content is relatively restricted, with perhaps just two or three dominant colours. Colour contrast especially has the most powerful effect, when a single colour subject is set against a background of the opposite hue, a red-sailed boat on a blue sea for example.

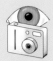

The Key To

The key to shooting colour photographs that have real impact is to be fully aware of precisely what colours are present in a subject and where they are. It is usually very colourful scenes which inspire most people to take out their cameras but the outcome is often disappointing

"The most striking colour images will invariably be those where the colour content is relatively restricted"

Puerto de Larreau

I like mountain passes and on my trips to Spain I try to find a different way across the Pyrenees each time I travel. This picture was taken from one of my favourite passes, the Puerto de Larreau, which I crossed in late autumn. The bands of colour were the prime interest for me but I also felt the pools of light created by gaps in the cloud were an important element as they have added a good range of tones to the purely colour element of the image. The scene lacked an obvious focus of interest and to some extent the areas of highlight have compensated for this, helping to lead the eye into the picture. Although the colours are quite bold there is a harmonious quality as they fall mainly into the same area of the spectrum.

the monochrome view

Just as a subject needs to be seen in a particular way for colour photography, so shooting in monochrome needs another very different visual approach. Many photographers, myself included, dislike having to shoot colour and black and white on the same assignment because the two disciplines are so different.

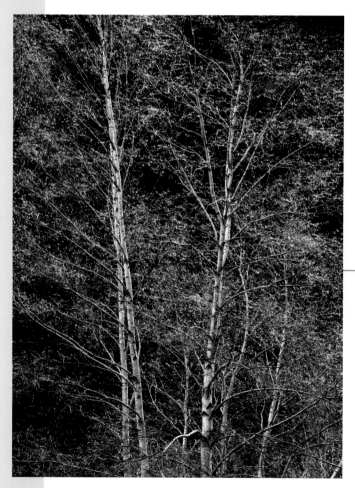

Tree Dew

This picture was taken during a winter trip to the Pyrenees. I'd spent the night in a hotel close to the summit of one of the passes. On setting out for the day, I discovered a very heavy frost had coated the countryside giving it the appearance of a snowfall. I had already taken a number of photographs of this view when the sun began to warm the air and the frost started to melt leaving thousands of tiny water droplets clinging to many of the trees and branches. Although the sunlight had not yet reached this group of trees the sky was bright enough to illuminate the dewdrops into minute specks of pure light. The mountainside behind lay in shadow creating a near black backdrop and giving the image a striking tonal quality. I used a long focus lens to isolate the most interesting section of the trees and framed the image so that the most dominant trunks created lines, which divided the image roughly into thirds.

It's essential to ignore the colour content of a subject when shooting in monochrome and learn to look only at the tonal graduations it possesses. Colour can be a real red herring because it can mask the tones of a scene. A still life of a single red apple in a basket of green ones, for instance, would look quite striking because of the contrast between the colours but in black and white the red apple would be a very similar tone to the green ones. Without the technique described on pages 68-69 the result would be a flat and uninteresting image. Good monochrome images depend on more than just contrast, however, and elements such as shape, form, texture and pattern are vital for the production of strong, eye-catching photographs.

"Good monochrome images depend on more than just contrast"

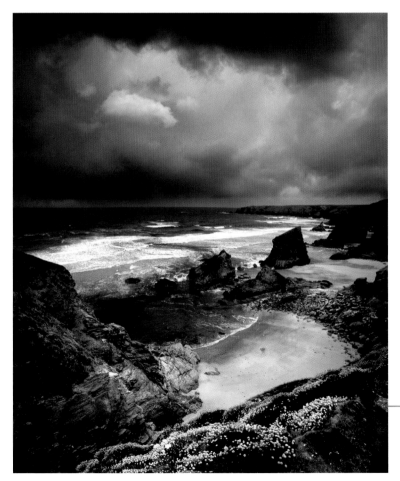

Bedruthan Steps

Bedruthan Steps in Cornwall is a popular viewpoint for photography. It was late spring at the time of my visit and the very thick cloud had created a soft overall light but some thinner areas had helped to create a good range of tones in the sea. I was lucky that the plants in the foreground were light in tone as this added a valuable tonal variation and helped to lead the eye into the image. I used a wide-angle lens to include both the close foreground and a large area of the sky and set a small aperture to ensure there was enough depth of field to give sharp focus throughout the image. I waited until the waves broke before making my exposure to provide the essential area of light tones in the middle distance.

using light

The ever-changing interaction between light and the landscape is one of the most fascinating and challenging aspects of this type of photography and one which can make it both exciting and very frustrating.

Las Alpujarras

The Alpujarra Mountains lie to the south of Granada in southern Spain and are, in effect, the foothills of the Sierra Nevada. Although fiercely hot in the summer months they can be bitterly cold in the winter and snowfalls are not uncommon. I arrived a week or so after the countryside had been blanketed with snow and only a few patches remained uncovered. I rather like this effect and find it more interesting than when everything is white. The sky was quite overcast and the light very diffused with almost no shadows but the virtually black and white nature of the scene produced enough contrast to make the image work. Using a long-focus lens to isolate a small area I framed the image so that the almond trees were at the very top of the picture and the patches of snow became a foreground.

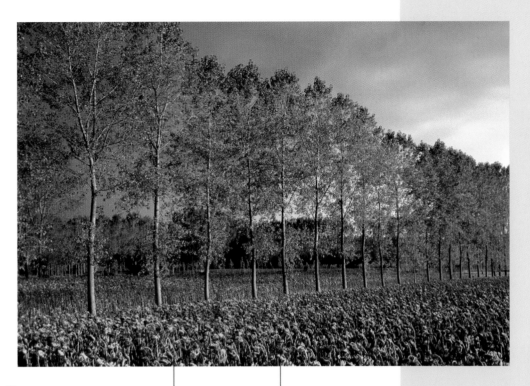

Trees and Sunflowers

I was driving along the Loire Valley in late summer when I spotted this row of trees bordering a field of sunflowers, which were almost ready to be harvested. I was attracted to the scene by the orderly arrangement of the trees and the colour combination of the trees and foliage. But it was really the quality and direction of the light that clinched it for me as it had created a striking effect on the tree trunks and branches, making them stand out clearly from the rest of the scene. The slightly cloudy sky also added to the mood and colour quality of the image. I chose a viewpoint, which separated the trees well and created a pleasing perspective along the row.

"The light created a striking effect on the tree trunks and branches, making them stand out clearly from the rest of the scene"

The quality and direction of light is crucial to the creation of an eye-catching image. An essentially uninteresting subject can often be transformed into a powerful and evocative image simply by the way it is lit. The key to becoming fully aware of the way light affects a subject is to study the shadows. Ask yourself, how dark are they, how big are they, what direction do they take and how soft or hard are their edges? Another way of understanding just how much the quality and direction of light alters the appearance of a scene is to study its effect regularly on a familiar view, from one of the windows in your home, for instance, or a favourite location you visit frequently.

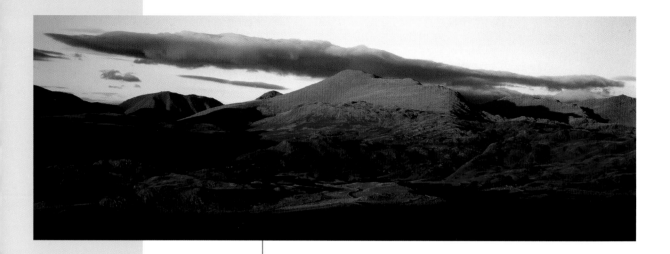

There are a number of landscape photographers who are reputed to only shoot during the first and last few hours of the day when the sun is at a low angle. However, I find that many of the shots I'm most pleased with have been taken around the middle of the day, including a good many when there's been no sun but just overcast skies. But I see their point, as there is a beautiful, mellow colour when the sun is close to the horizon. The acute angle the sun forms with the landscape can reveal both texture and form within the contours of the land. It is a valuable period of the day and it is worth planning an itinerary so you can take advantage of these conditions and look for viewpoints, which will make the most of such lighting. Sunsets and sunrises also offer potentially the opportunity for eye-catching images; so too do dusk and dawn when, even on a cloudy day, interesting and atmospheric effects are often created.

Cumbrian Mountains

As the sun approaches the horizon it often softens a little, even on a day with a clear sky, because it passes through a thicker layer of the atmosphere and the effects of any haze is magnified. I've been to a few places, such as the south west of USA and Australia, where for much of the year the atmosphere is so clear that it's not uncommon for the sunlight to retain a sharp clarity right until the very last moment. In my experience, however, these conditions are relatively rare in Europe. Consequently, on this occasion driving through the mountains of Cumbria in the late autumn, I was thrilled to see this lighting effect just a few moments before the sun disappeared. I used a long focus lens to enlarge this section of the scene and framed the shot so that all of the long cloud was included. I cropped the image to make a panoramic shape and removed most of the deeply shaded foreground as well as an excess of sky above the cloud.

"There is a beautiful, mellow colour when the sun is close to the horizon"

Lee Bay

This picture of a small bay in North Devon, England, was shot just after sunset on one of those lovely, still summer days. This had been a typical sunset, with the sun softening and weakening considerably as it approached the horizon, and my plan to catch the last rays as they glanced off the headland were thwarted. But as I sat watching the scene evolve I realized that the lighting quality was now very interesting. Although the overall colour of the sea and sky were a purplish blue there was just enough red tint in the distant clouds to add an element of contrast. The reflections in the calm water of the high tide were also a crucial factor and I framed the image to include the headland and a wide expanse of the sea. I cropped to a panoramic shape to exclude the less interesting areas of sea and sky, which the wide-angle lens had included.

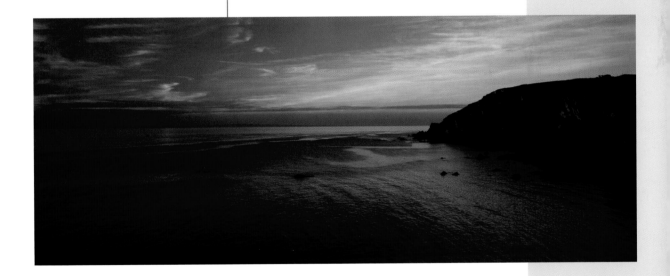

choosing a viewpoint

Choice of viewpoint is one of the most crucial decisions to be made, especially in landscape photography where the subject itself is invariably fixed. Exploring potential viewpoints is one of the most enjoyable and revealing aspects of photography.

"Choosing a viewpoint is rarely something that can be done in isolation"

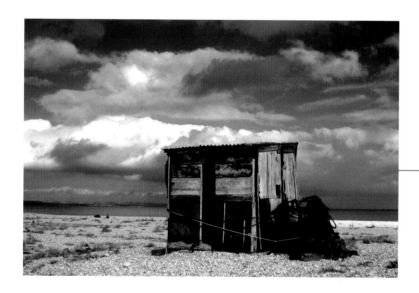

Those who shoot from the spot from where they first see a subject, and don't look at other possibilities, are not only missing some of the creative pleasures of photography but are also not very likely to get the best result. It's also important to appreciate that choosing a viewpoint is rarely something that can be done in isolation. For example, changes in the light and how the image is to be framed are both likely to influence the choice of viewpoint. Exploring potential viewpoints is also an excellent way of developing a good eye for a picture and a feeling for composition.

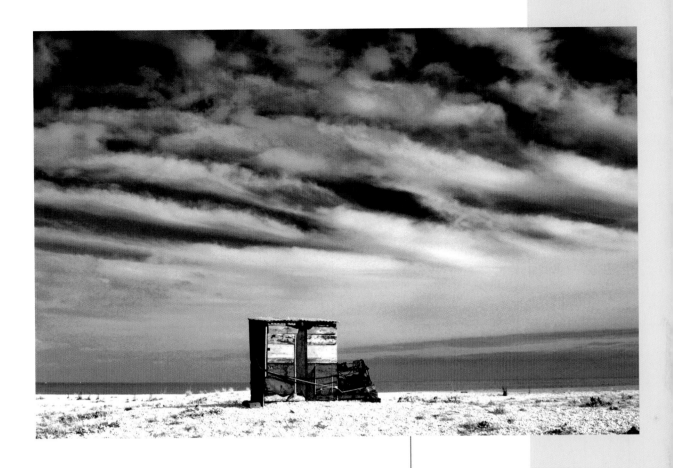

Fisherman's Hut

Dungeness beach in Kent is one of my favourite places. It's bleak, usually windswept and far from pretty but I almost always find something there to photograph. There are a number of small huts dotted around where the fishermen keep their nets and other equipment but this one caught my eye because it was very close to the sea and there were no distracting objects nearby. My first choice of viewpoint (on the opposite page) was based on the desire to show a little of the sunlit side of the hut and to include the rather nice cloud formation behind it. As I stood taking my shots I saw there was an even nicer bank of cloud forming to my right. In order to include the new cloud I moved my viewpoint some distance to the left, and quite a lot further from the hut. For the picture above, I then aimed the camera upwards more to include the full expanse of the cloud formation. I used Channel Mixer in the way described on pages 68–69 to convert the images to monochrome. In the case of land 2 I reduced the blue and increased the red, to make the sky darker and clouds stand out in greater relief, but with land 1 I aimed for a less dramatic tonal rendering.

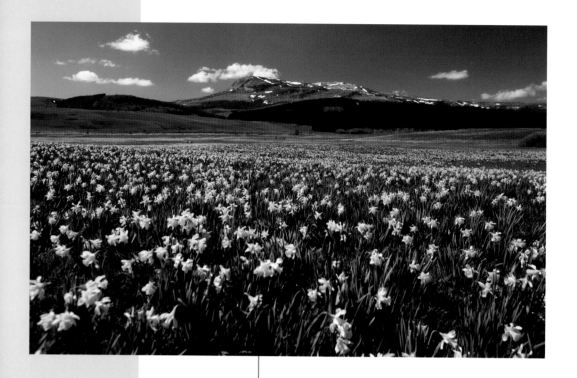

Auvergne Daffodils

While traveling through the Auvergne region of France in the late spring I came across this wonderful display of wild daffodils carpeting the meadows almost as far as the eye could see. Although this view was not the easiest spectacle to capture on film I settled for shooting the picture using a very wide-angle lens from only a foot or so above ground level. This enabled me to include a large area of the scene but at the same time show some of the blooms reasonably close up. I focused at a point about five metres in front of the camera and set my smallest aperture to obtain maximum depth of field. Even so I would still have liked the closest flowers to be sharper. I used a polarising filter to increase the colour saturation and show the clouds in greater relief.

Choice of viewpoint is critical because, for many of the subjects a photographer shoots, the viewpoint is by far the most important control over the content and composition of his or her images. The viewpoint has an enormous effect on the relationship between objects at different distances from the camera and, correspondingly, the impression of perspective. When the camera is moved to the right objects close to the camera will appear to move to the left of more distant details and vice versa. Moving the camera closer to foreground objects will make them seem significantly larger in relation to background details, while a more distant viewpoint will make them seem smaller. This maneuvering helps to control the effect of perspective in an image.

When there are close foreground details in a picture as well as distant ones the image has a greater feeling of depth and distance. This perspective can help to create the illusion of a third dimension. But when there is a lack of foreground interest the image will appear flatter and the perspective more compressed. Choice of lens and the corresponding field of view will heighten these effects. A wide angle lens used with very close foreground objects will exaggerate the impression of depth and distance, for example, while a very long focus lens focused on distant objects will virtually eliminate it and create images with a much flatter, more graphic quality.

> **"When there is a lack of foreground interest the image will appear flatter"**

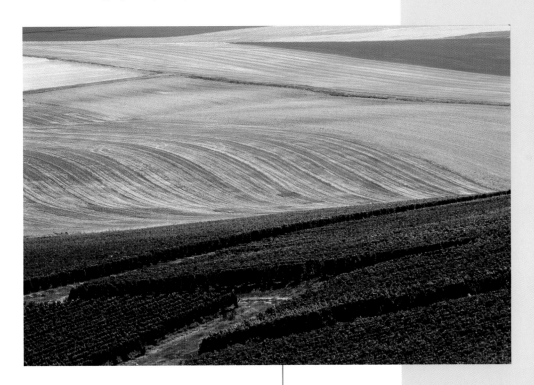

Champagne Vines

This picture was taken from one of my favourite viewpoints in France, which I visit whenever I am in the vicinity, as much for the view as for the promise of photographs. The place is a hill called Mont Aimee that rises above the plain of Champagne to the south of Epernay. The grape vines are planted on the slopes of the hill and the plain is a chequerboard of wheat fields and other crops. I used a long focus lens to shoot this image in order to focus the attention on a small area of the scene where the contrast between the dense green vines and distant pastel fields was strongest. This also had the effect of creating a compressed effect with the fields seemingly closer to the hill slope than they really are.

framing the image

The camera's viewfinder can be compared to a painter's canvas in so far as what it contains is entirely under the control of the artist. Admittedly, the person with the brush has much greater freedom and flexibility but a photographer is just as responsible for what appears inside his or her frame.

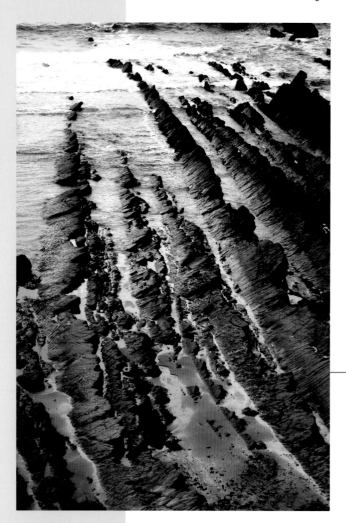

Welcombe Mouth

These interesting rock formations are to be found on the North Devon coast. My visit on this occasion was on a dull, overcast day when the light was very soft but the inherent contrast of the scene made me think it would work as an image. I was lucky because the tide was at the stage where just enough of the rocks and a little of the sand were exposed to add an element of texture and colour. From my high viewpoint I had the freedom to angle my camera in a variety of ways but I chose this section because the line of rocks created a strong diagonal shape. I used my zoom lens to frame the image so that only the essentials were included in order to maximize the impact of the shapes and textures.

It's a common fault for even quite experienced photographers to see their pictures by eye alone and use the viewfinder simply as a means of aiming the camera. However, this method has many potential pitfalls. The most common drawback is for significantly more to be included in the frame than was intended and for distracting elements to appear in the photograph that were not noticed at the time of shooting.

Having chosen the most effective viewpoint for a shot the next step should be to study the image on the viewfinder screen. Carefully scan the image from the edges of the frame into the centre so that you are aware of every detail it contains. Then you must decide whether more or less of the scene needs to be included, either by altering the viewpoint or by changing the focal length of the lens. The frame then needs to be positioned, by angling the camera, so the key elements of the image create a balanced and harmonious arrangement within it.

> **"It's a common fault for even quite experienced photographers to see their pictures by eye alone"**

Sausage Tree

The curious sausage tree is quite a common sight on the plains of Kenya's Masai Mara but this one was a particularly nice example with a good shape, leaning at a nice angle and perfect lighting. I felt the plain blue sky was also ideal because it did not distract from the tree's shape and created excellent separation. I chose a viewpoint that showed the tree's best aspect and one that was low enough to separate the lower branches from the grass. I framed the image in a way that placed the tree a little to one side and included the two small, distant trees in the distance on the left to create an element of balance.

understanding exposure

Getting the exposure right has always been a major preoccupation with photographers working with film, especially with those, like myself, who shot primarily colour transparencies. With colour transparencies the exposure not only determines the basic technical quality of the image but also sets the density and contrast of the final photograph.

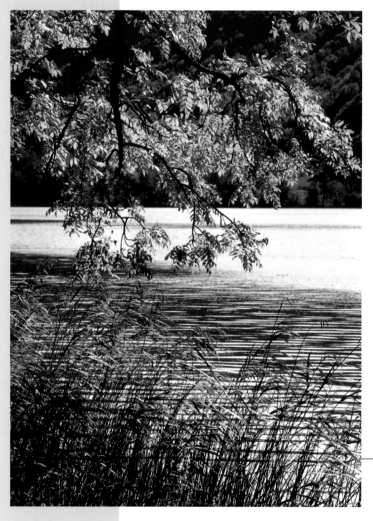

Reed Lake

As I drove along the shore of a lake in eastern France late in the afternoon of a sunny, autumnal day I was struck by the backlit foliage of this tree. This effect, combined with the striking patterns and textures created by the gently rippled water and the reeds, made me want to photograph the scene. On checking the exposure reading I realized the bright highlights on the foliage and water were indicating considerably less exposure than was needed to avoid detail being lost in the darker areas of the scene and I set my exposure to give one and a half stops more.

Surf and Sunset

A foreground of water is ideal for photographing sunsets because the colour in the sky is echoed which heightens the impact of pictures like these considerably. In the summer the sun goes down much further to the right of this scene and disappears behind the headland long before it sets, but in winter the sun sets over the sea. This shot was taken in late autumn, which allowed me to use the headland as an additional element of the composition. I took my exposure reading from an area well to the left of the sunset making sure that the sun itself did not influence the reading. This indicated an exposure of three stops more than when the reading was taken from the scene I wanted to photograph. This latter reading would have resulted in an extremely underexposed picture.

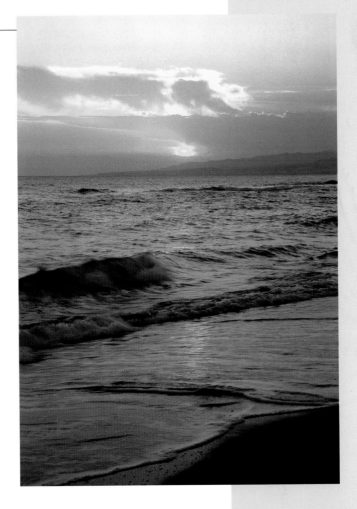

The Key To

The key to avoiding exposure errors lies in learning to judge when a scene has larger than average areas of very light or dark tones. Less exposure is required when the subject contains large areas of very dark tones, such as deep shadows, and more with very light tones or bright highlights.

"Situations needing more exposure than the camera suggests are more commonplace"

No metering system is infallible and there are situations when it is necessary to modify or compensate for the reading given by the camera's exposure meter. Situations needing more exposure than the camera suggests are more common place than when less exposure is needed and the two most frequent causes of underexposed pictures are when shooting into the light and photographing a sunset.

using depth of field

Image sharpness is a key factor in the technical quality of a photograph and much of the efforts in developing both photographic equipment and materials have been with the aim of improving it.

Red Rock

The Rio Tinto mining area of southern Spain is a fascinating place, so rich in colour and texture that some of the rock formations could almost be art installations. I very much liked this big slab of red rock, about three metres high, partly for its shape and colour but also because it was so nicely lit. I chose a viewpoint that showed its shape well and which placed it in front of the huge mountain-like rock in the middle distance. I framed the image, using a wide-angle lens, to include a little space below the foreground rock and some of the sky above the background rock. I used a polarising filter to increase the image's colour saturation. I also set a small aperture to give me maximum depth of field and to ensure the image was sharp from front to back.

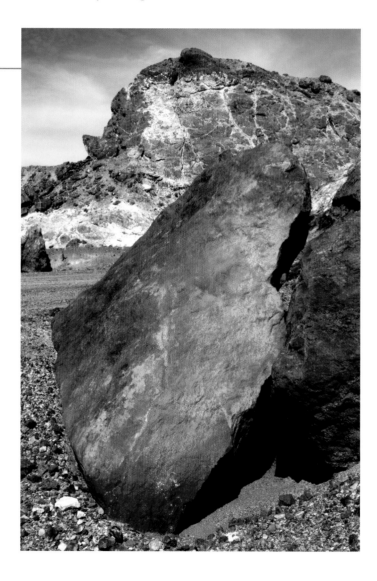

The two most common problems in achieving good definition have little to do with lens resolution and are the result of either the camera or the subject moving during the exposure. A moving subject must usually be dealt with by using a fast shutter speed but camera shake is best avoided by using a tripod.

Controlling image sharpness is a very useful tool in photography. We tend to see everything as equally sharp with normal vision but the camera only records the details upon which it is focused with optimum definition. Objects both closer and further from the camera begin to become progressively blurred. The range of acceptable sharpness can be increased by the use of small apertures, creating greater depth of field. But it is often desirable to restrict the depth of field, so that objects in sharp focus will stand out more clearly from background details, and a wide aperture must be used for this.

"It is often desirable to restrict the depth of field"

Thistle

I spotted this rather fine thistle beside the road while driving through the mountains in Andalucia. It was a cloudy day with soft light and this suited the subject well because sunlight would have created too much contrast. I chose a viewpoint that showed the best aspect of the plant and placed it against a background of half sky and half landscape. I wanted the thistle to stand out boldly from the background so I set a wide aperture using a long focus lens. This also helped me to limit the area of background and have more control over it as well as making the depth of field shallower.

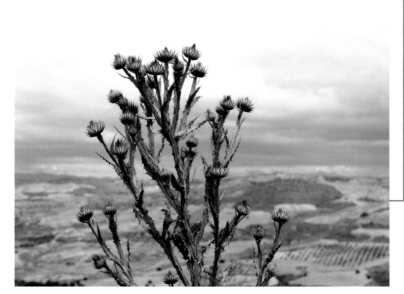

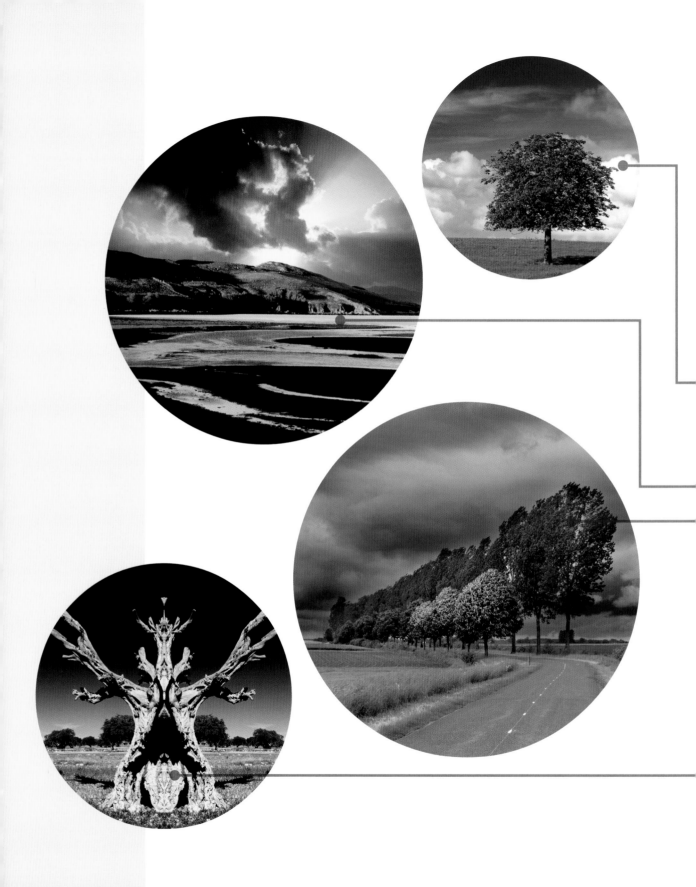

10 steps to enhancing images

creative cropping

The great reportage photographer Henri Cartier-Bresson is reputed to have never allowed his photographs to be cropped. He always insisted that they were shown as he composed them in the viewfinder and captured at the moment of exposure.

Many fine art photographers working with black and white film have the same attitude. They often print their images with the film rebate visible so that it is evident they have been shown as captured. I have to confess that I too like to try and fill my viewfinder frame with only the elements I want my image to include. However, those who buy and use images have no such compunction and do not hesitate to crop an image to fit a page or layout when necessary.

original shot

Tree and Clouds

An autumnal trip to Burgundy, France provided the opportunity for this shot. I was attracted initially by the tree's pleasing shape and the fact that it was nicely lit. The sky was also quite attractive and provided a contrasting background against which the tree stood out clearly. The fact that some of the leaves had turned colour added some interest to the image. I used a long focus lens from a fairly distant viewpoint, which was chosen so the tree appeared between the two nice billowing clouds. I framed the image as a horizontal shape with the tree virtually central and left space above it to create what I felt was a good balance.

On downloading the image I began to have doubts as to whether the balance I thought I'd achieved was the best I could do. I used the Crop Tool to try some alternative shapes and positions and I was surprised to find more options than I'd anticipated. I was uncertain about which shot I liked best but ultimately thought the semi panoramic shape worked really well with the tree placed a bit more to one side.

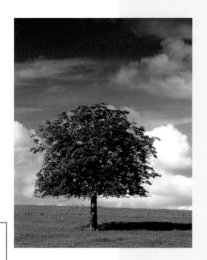

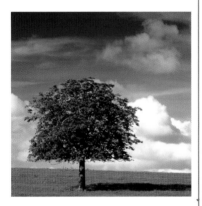

"I used the crop tool to try some alternative shapes and positions"

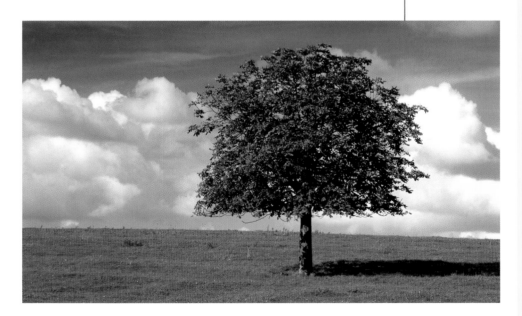

adjusting density & contrast

The first thing I do after downloading an image onto my computer, and cropping when necessary, is to adjust the density and contrast to create the effect I visualized at the time of shooting. As with many image-editing functions, there are a variety of ways of doing this.

The Key To

The key to obtaining the maximum degree of control over image quality and the ability to fine tune in a very subtle way is to use either Levels or Curves. Although Auto Levels and Auto Contrast are quick and easy fixes they cannot interpret the image and render it in the way you have visualised.

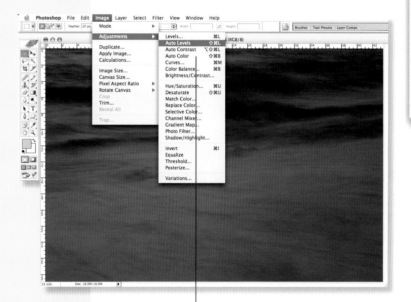

The easiest way to control density and contrast is to go either to Auto Levels or Auto Contrast in Image>Adjustments. Auto Contrast adjusts the image so the lightest tones are rendered as white and the darkest as black. Auto Levels does a similar thing but adjusts each colour channel individually. Although in many cases there will be little difference Auto Levels can have a dramatic effect with some images, especially when there is a colour cast. I usually have a look to see what effect Auto Levels will have before proceeding to adjusting with Auto Contrast or Curves.

original image

Swirling Tide

I walked down to the edge of the sea on this Spanish beach just before sunset and waited until the sun had disappeared below the horizon before taking this shot. I wanted to capture the reflections of the red clouds, which were contrasted with the blue water still being lit by the sky. I also wanted the light level to drop so that I could use a slow shutter speed and create this blurred, swirling effect.

The original image as it was captured and down loaded needed considerably more contrast and to be lighter. Using Auto Levels created the effect seen in the second image with the colours much more clearly separated and lighter overall. This was too much so I went to Edit and used Fade>Auto Levels to reduce its effect to about 60%. This was more like it but the image was now too light and still too soft. I next used the Curves control to increase the contrast and reduce the density to create the image quality I had visualised shown with final image.

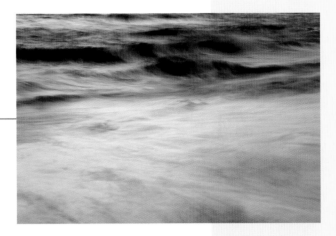

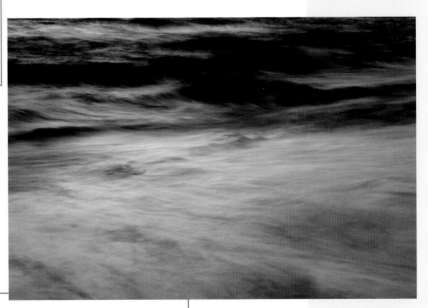

contrast control

When a captured image lacks contrast this can usually be overcome quite easily with the use of Auto Levels, Auto Contrast, Levels or Curves. But these methods are seldom satisfactory when used to reduce the contrast of an image. A very effective and simple method is to use a contrast mask. This is a technique that was previously used in the darkroom, which was quite time-consuming and laborious but now, using image-editing software like Photoshop, is quick and easy.

River Borgie

The river Borgie lies in the very north of Scotland and is one of its finest salmon rivers. I was there for the fishing in late autumn but the weather was so good that the prospect of capturing a few good photographs seemed a lot better than catching a fish. But the sunlight was so strong and the atmosphere so clear that this scene was very high in contrast and I knew would produce a rather harsh looking image with little detail in the highlights and dense, blocked up shadows. But I decided to shoot it anyway, with the knowledge that I might be able to adjust it in Photoshop, and set an exposure based on recording the mid tones accurately.

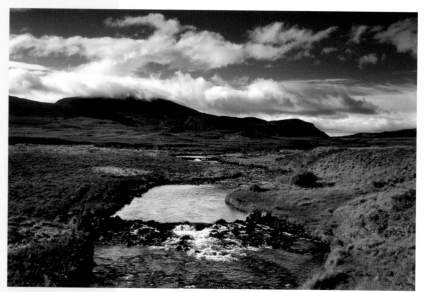

original image

My first step was to make a
duplicate layer and set the blend
mode to Overlay. I then rendered
this layer in black and white using
Image>Adjustments>Desaturate
and next inverted it to create a
black and white negative using
Image>Adjustments>
Invert.

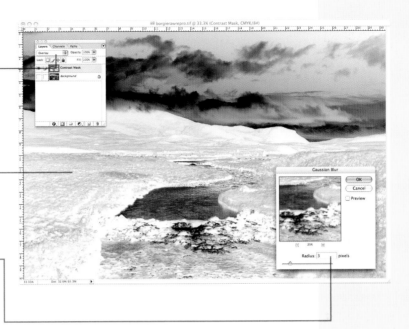

I next applied a degree
of Gaussian blur using
Filter>Blur>Gaussian
blur, setting the slider to a radius
of 3 pixels. I fine-tuned the
effect of the mask by adjusting
the opacity of the mask layer
and also by altering its density
and contrast using curves.

**"A contrast mask is
a very effective and
simple method for
reducing contrast"**

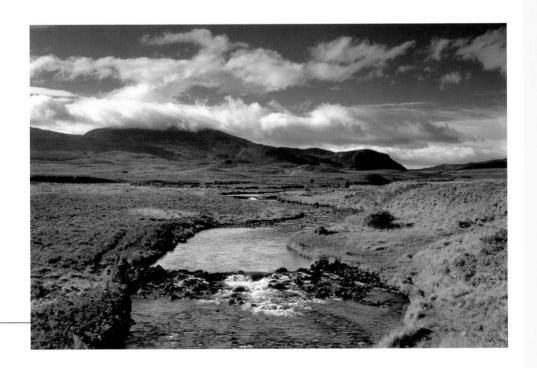

controlling colour

Light varies in colour enormously from the orange hue of a setting sun to the strong blue bias of open shade under a blue sky. Add to this the range of colours that artificial lighting can create and the possibility of a subject being captured with its true colour is seemingly slight.

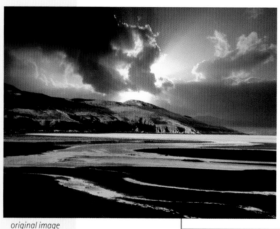

original image

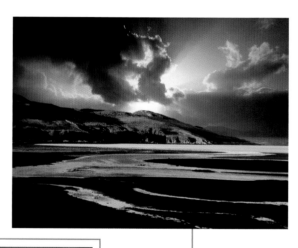

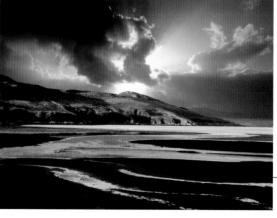

Scottish Coastline

The **first image** here shows the colour quality of the capture while **the second** shows the effect of reducing the colour saturation by a factor of 20. The **third image** is the result of increasing the colour saturation of the captured image by a factor of 20.

This is a major consideration with film but digital cameras have an automatic white light balance that largely overcomes the problem. Most captured images will display a fairly accurate rendition of the colours in a scene, but if the colours in an image are inaccurate, or simply not to your taste, there are a number of ways of changing them.

The Hue and Saturation sliders found in Image>Adjustments are the most basic way of varying the colour quality of an image. Hue alters the colour bias of an image from blue through green to red, while Saturation changes the purity of a colour. When this is a minus value it creates a weaker, more pastel hue, while a positive value makes the colour much richer and stronger. This can be done overall or with each primary and secondary colour individually. For example, 1 find reducing the red saturation an effective way of making the skin tones in a portrait more flattering. A more flexible and subtle way of achieving a similar result is to use Levels or Curves wherever it is possible to alter the colour of individual tones, for example making the highlights more blue and the shadows more red. The permutations with this method, especially using Curves, are virtually endless.

"The permutations for changing colours, especially using Curves, are virtually endless"

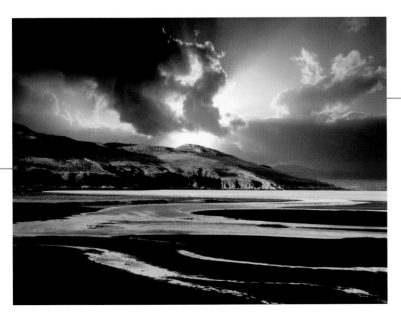

I used the Curves control to adjust the colour of the fourth image. I increased the amount of red in the highlights and mid tones, reduced it in the shadows and used the blue curve to increase this hue in the shadows and reduce it in the highlights and mid tones.

accentuating skies

The sky is often a crucial element of landscape images and, in many cases, determines the success or failure of a particular picture. Even when the sky is interesting and has a good range of tones it can be difficult to capture successfully.

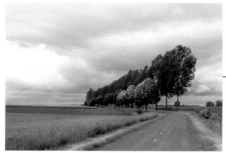

original image

"The sky is often a crucial element of landscape images"

The reason is simply because the sky is effectively part of the light source for a landscape. An exposure that will record adequate detail and a good range of tones in the landscape is likely to result in the sky being over exposed, with a corresponding loss of tone and detail. Those accustomed to using black and white film will know that in the darkroom it is possible to use printing in and dodging techniques to correct this fault in a limited way. Those shooting on transparency film are able to use neutral-graduated filters to achieve a similar effect. But compared to the methods of control available with image editing software, such as Photoshop, these techniques now seem quite crude and restricted.

There are several ways in which a sky can be accentuated using digital techniques, depending upon the nature of the subject and elements like the horizon. Where the skyline is clearly defined, such as in a seascape or a mountain scene, it is possible to simply select the sky area using the magic wand tool and alter the density and contrast of the sky directly. But when there is a more complicated division between land and sky it's necessary to use other methods.

French Country Road

I spotted this line of trees from some distance away as I drove along a quiet country road in northern France and when I turned the bend it presented a very pleasing shape. Although the light was very soft and cast only very subtle shadows I felt the scene had an appealing quality when viewed in conjunction with the gentle graduations in the sky. I realized that the captured image would result in the sky being much lighter and less contrasty than it appeared visually because of the exposure needed to record the foreground. However, I felt confident that this could be overcome at the image editing stage.

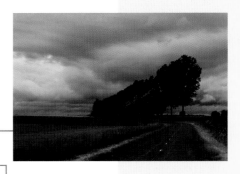

After adjusting the levels of the downloaded image I made a duplicate layer of it. I then adjusted the density and contrast of the sky in the copy layer to achieve the effect I wanted, ignoring the effect this had on the landscape. I next made a mask of this layer and, using a large soft-edged brush set to low opacity, I painted in the darkened sky leaving the trees and fields from the original image underneath to show through.

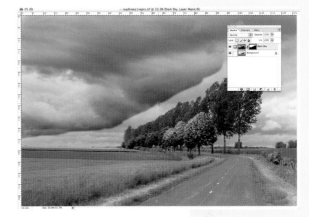

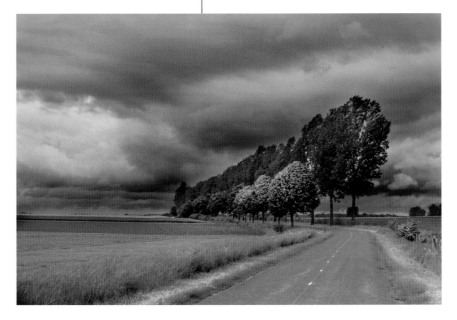

adding skies

The essence of landscape photography lies in the coming together of landscape, light and sky in a way that stirs the senses. You only have to look at the works of photographers like Ansel Adams and Michael Fatali to see just how powerful an image can be when these three elements have been captured at the crucial moment. This is not to suggest that striking landscape images cannot be produced when one or more of the key elements are missing; it's simply that when all three are present in an image the result is likely to be exceptional.

Snow River

A winter's afternoon in the foothills of the Spanish Pyrenees provided this photographic opportunity as I crossed a bridge over the river. The low angle of the late sun created some nice texture and clarity in the image. The snow capped mountains also stood out clearly from the blue sky and I used a polarising filter to accentuate this further.

The captured image was quite pleasing but I felt it was a bit too bland which I attributed to the plain blue sky. I found a sky in my collection that I thought would be compatible and opened this image as well, placing them side-by-side on the desktop. Using the hue and saturation controls, I adjusted the colour of both skies until they were a reasonable match. I then added some extra canvas to the river image at the top and copied and pasted the sky image onto it on a separate layer. I next made a mask of the sky layer and, using a large soft edged brush set to a low opacity, painted away the new sky until it blended with the original sky underneath.

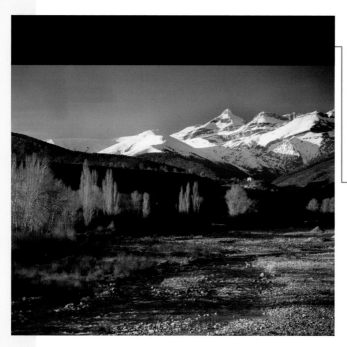

I'm sure that I'm not alone in having encountered many situations where I've seen a stunning view capped with a dramatic sky but the light on the landscape has been unexciting, or when a beautifully lit landscape has a bland and boring sky. However, with image editing software it is possible, in some circumstances, to add the missing ingredient of a more dramatic sky. There are a number of ways of doing this. When the landscape has a clearly defined and uncluttered skyline it can be possible to simply select the landscape area, copy it and then paste it onto a suitable sky. When this is not possible the masking method can often be used successfully.

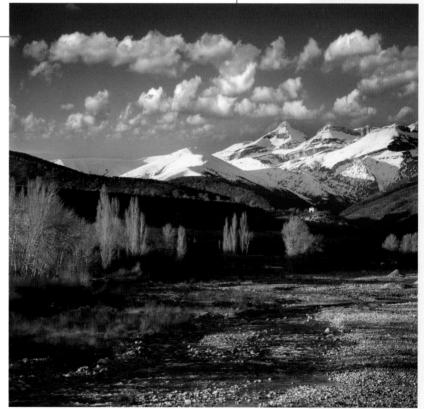

"The low angle of the late sun created some nice texture"

😐 😐 😐 **The Key To**

The key to adding a sky is in finding one which is compatible with the landscape image. Even if there is no intent to convince the viewer that it was a straight capture, the result will not be pleasing if the tone and colour of the sky is at odds with that of the foreground.

using special effects

The ability to create special effects using digital manipulation is almost limitless and there is a distinct temptation for those new to the process to use it to extremes, I know I did and still sometimes do. Although some of the effects are very questionable from an aesthetic point of view, nonetheless using special effects can be a great deal of fun.

Waterfall

This picture was taken on an overcast day when the light was very soft, both conditions which suit this type of subject very well. I used a slow shutter speed to render the fast flowing water as a homogenous blur to create a range of smoothly graduated tones.

The resulting image had some nice qualities but lacked interest because there was little in the scene to provide an effective foil to the blurred water. I decided to create a pseudo polarised effect by employing a method I'd discovered previously with a similar subject. I began by making two copy layers of the image and, with the second, top layer switched off, I used Image>Adjust>Invert to render it as a negative and then set the blend mode to Difference. I double clicked on this layer to bring up Layer>Style and used the sliders in Blending Options to adjust the effect being created. This left the shadows of the image as a light tone, so I switched on the top layer and set the blend mode to Darken to overcome this. I then made final adjustments in Blending Options before flattening the image.

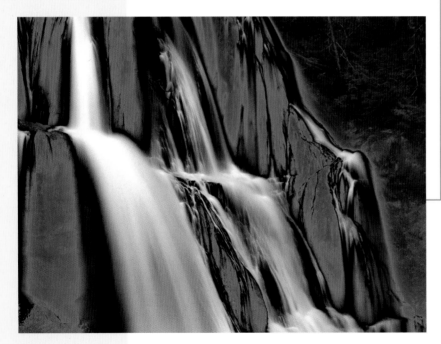

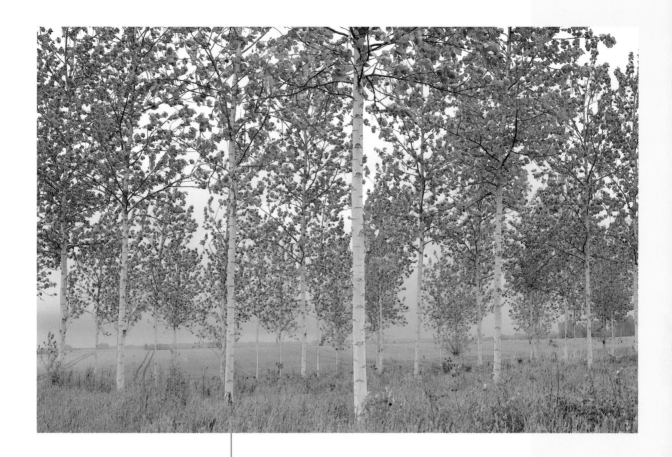

Saplings

The soft colours of this small plantation of trees attracted me and I also liked the sketch-like quality of the scene. The colour was enhanced by the almost shadowless light of a cloudy day, which helped to reveal the subtle details in the trees. I chose a viewpoint and framed the image

in a way that created a pleasing juxtaposition of the trees and an almost symmetrical composition.

I was quite pleased with the captured image but felt it might be improved if I could accentuate the delicate sketch-like quality of the scene. To accomplish this I made

a duplicate layer of the image and applied the Find Edges filter found in Filter>Stylize and set the blend mode to Darken. I fine-tuned the effect by using Curves to alter the density and contrast of the filtered layer before flattening the image.

converting to monochrome

There are a number of ways of doing this and the simplest is to go to Image>Mode and select Grayscale. But this method discards all of the image's colour information and you forfeit the ability to use this as a means of altering the tonal rendition of the image.

Going to Image>Adjustments and selecting Desaturate will also render the image as a monochrome but will still leave you with the opportunity to introduce a colour tone if required. Using the Channel Mixer is a method which allows you to have considerable control over the tonal rendition of a monochrome image in a similar way to using colour filters when shooting with B/W film, but with far more flexibility.

> **"The Channel Mixer allows you to have considerable control over the tonal rendition of a monochrome image"**

The Channel Mixer is found in Image>Adjustments and by clicking the Monochrome box the image is displayed in monochrome. By using the sliders you are now able to make colour layers in the image either lighter or darker. Setting the Blue slider to a minus value will make a blue sky in the image much darker, similar to the use of a red filter with B/W film, while setting the Green slider to a plus value will make green foliage much lighter in tone. With the right subject this can produce a result very similar to that created by infra red B/W film.

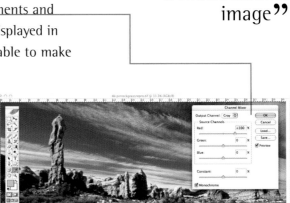

Arches

The Arches National Park in Utah, USA provided the setting for this picture which was taken on a wide-angle lens using a small aperture for maximum depth of field. I used a polarising filter to make the sky a deeper blue and to accentuate the clouds.

The **second image** shows the effect of converting from RGB to Grayscale which has produced a reasonably good range of tones. But by using Channel Mixer and

adjusting the sliders, seen here in the third image, I've been able to make the reddish earth and rocks lighter with greater tonal variation as well as helping to create a stronger and more dramatic quality in the sky and clouds. The foreground foliage has also been made lighter and brighter.

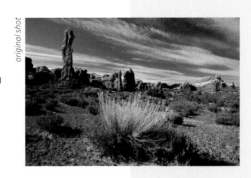

original shot

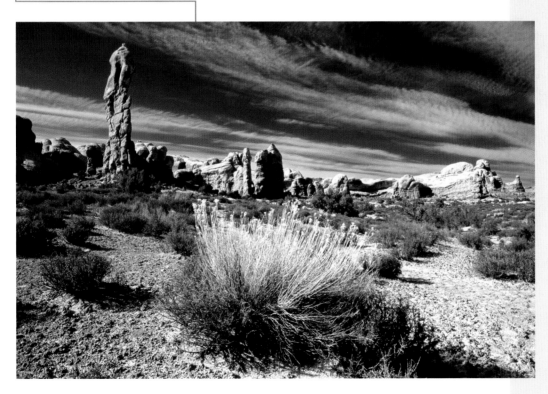

creating toned images

Few people would deny the dramatic impact of a strong black and white image, especially with a finely crafted print made in the darkroom on silver gelatin paper. These images are, however, often toned to add a hint of colour and those working with a digital image using ink jet printers can achieve a similar effect.

Twisted Tree

I saw this curiously shaped tree standing alone in a field as I traveled through the Moroccan countryside. I was struck not only by its strange contorted shape but also by the fact that it stood out clearly on its own and was well lit. I thought the captured image was quite striking but felt I could give a humorous touch by making a mirror image of it.

Making a Mirror Image

The first step is to crop the selected image along a line where you can visualize it being joined again. You can crop either vertically or horizontally depending upon the subject and the effect you want. Next add extra canvas on the side you want to mirror to the exact number of pixels as the cropped image. Using the Magic Wand tool select the extra canvas and then invert the selection so the half image is now selected. Copy this and then invert the selection again to reselect the extra canvas and paste the copied image into it. All that remains now is to flip the pasted copy using Edit>Transform.

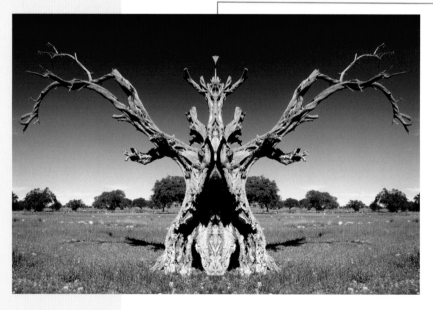

The **first** single colour version of this image was made using the **Gradient Map** found in Image>Adjustments. To do this you simply select two colours using the **Colour Picker**, in this case a dark, nutty brown and a pale, more golden hue. I then adjusted the contrast and density using Auto Contrast and Curves.

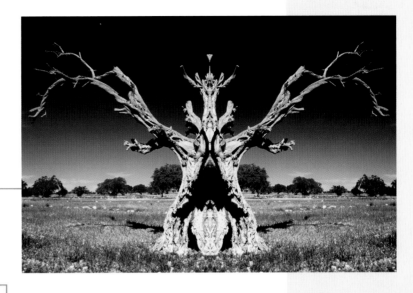

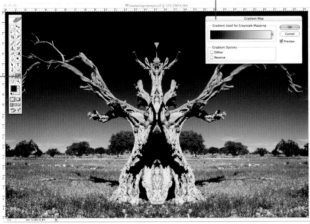

"There are several ways of digitally adding colour to a black and white image"

The **second version** was intended to emulate the effect of the darkroom technique of lith printing or split toning. My first step was to make a copy layer and then switch this off, allowing me to work on the original, background layer. I used Hue>Saturation>Colorize to give this layer a slightly bluish tint. Going back to the copy layer I used the same method to create a warm brown tint on the duplicate image. Double clicking on the top layer brings up the Layer Style palette. Here I used the sliders in Blending Options to adjust the blend between the two layers, aiming for an image with blue tinted shadows and sepia mid tones and highlights.

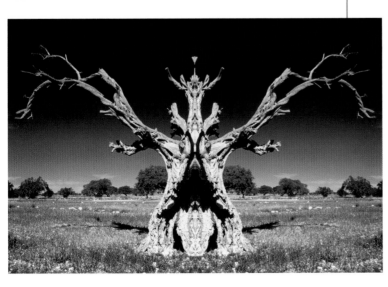

adding a border

No matter how stunning a photograph, or how good the quality of a print, both will benefit even more from good presentation. You can present prints by using bevel mounts and frames but it's also possible to make the image itself look more finished using image editing software. There are so many ways of adding an interesting edge to your images that your imagination becomes the only limiting factor. However, it's best not to become too carried away as you don't want to distract attention away from the image, or create a gimmicky appearance.

Valley of the Rocks

With this photograph of the Valley of the Rocks in North Devon, England, my first step was to add some extra white canvas to the image, and in this case I added 200 pixels wide all round. I next made a new layer and used the marquee tool to draw a selection on it creating a 100 pixel wide border on the new layer. I next filled this selection by using the colour picker tool to find a hue similar to one within the image. I now had a band of colour around the edge of the new, otherwise empty, layer and a white border of the same width around the original image. Using Layer>Layer Style I went to Bevel and Emboss using the sliders to create the impression of a bevel cut mount.

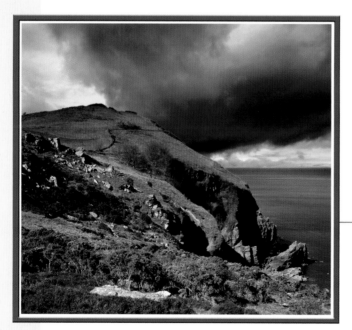

Gum Bark

I felt this close up image of the bark of a gum tree, photographed in Australia, had a quite painterly, abstract quality and I wanted to give it a border which had a similarly arty look. It's possible to buy software, which emulates the hand-made appearance of images like transfers, but for my taste they rarely look very convincing. This edge was created in the darkroom by filing down the negative carrier to allow light to leak though onto the print, a technique commonly used by fine art photographers. I simply scanned the print and erased the image leaving just the edge, which I then pasted onto a new layer above the gum bark image. I used Edit>Free Transform to adjust its size to fit. You could achieve a similar effect by painting or drawing a border on a piece of white paper.

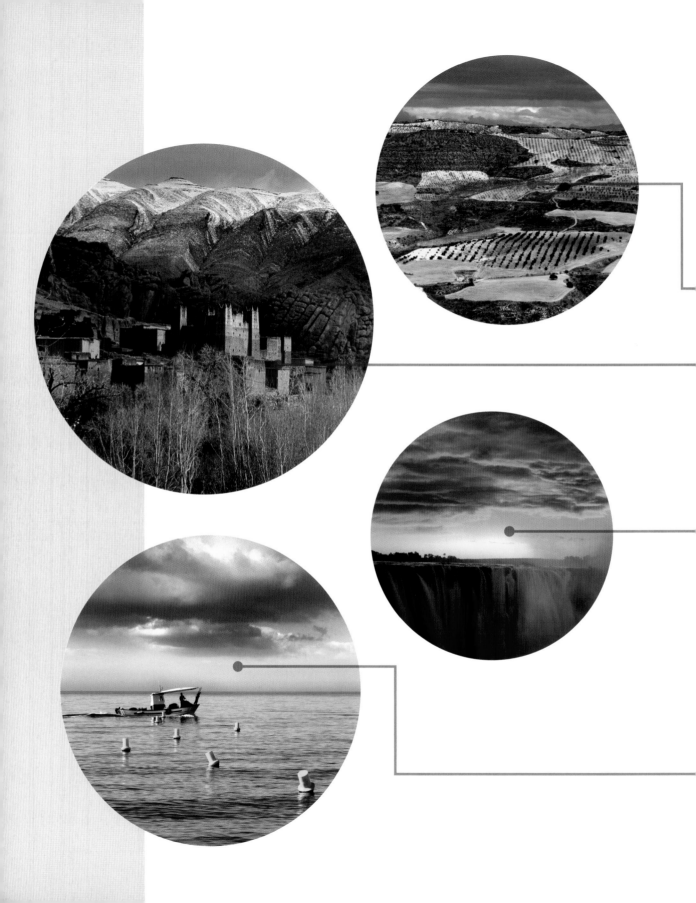

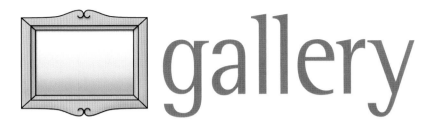

gallery

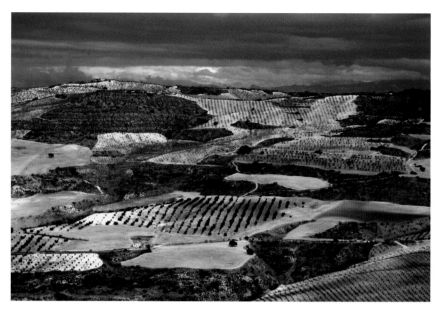

> **"I** used a slightly long-focus lens to frame the section of the land where the pattern was at its most striking**"**

Sierra de Tejeda

Capture

This unusual landscape can be found around the village of Alahama de Granada in the Andalucian province of Granada. I saw this particular landscape as I was driving through the region in the autumn. The fields of grain had been harvested and some of the stubble burned, which created a fascinating patchwork effect in conjunction with the olive groves and freshly ploughed areas. I came across this viewpoint on an overcast day when the light was quite soft, not usually the ideal conditions for photographing distant views. But the nature of the landscape and the dark sky created a quite dramatic effect and a reasonable degree of contrast. I used a slightly long-focus lens to frame the section of the land where the pattern was at its most striking. I also included an area of sky equal to about one third of the image area, which I felt produced the most pleasing balance.

Enhance

After downloading the image I adjusted the contrast and density using Curves to make the image slightly darker and a little more contrasty in order to accentuate the pattern effect and to increase the overall colour saturation. I then selected the sky area using the Magic Wand tool and made this area even more darker and contrasty. Using the Hue and Saturation sliders I also increased the cyan and blue saturation to exaggerate the colour of the blue-tinted clouds, which has made the contrast between sky and landscape even stronger.

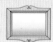

Lone Pine

Capture

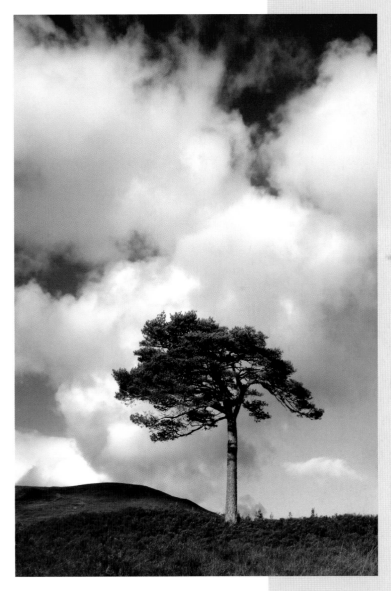

Most photographers have subjects, which they return to time and again. One of mine is isolated trees and I've built up quite a collection over the years. I spotted this one as I drove along the shores of Loch Etive in Scotland. It appealed to me because it was a very nice shape and was well separated from its surroundings. I also liked the tree because it was on a ridge above the road and had the sky as a background. The sky itself was attractive with some very pretty white clouds that helped to make the tree stand out boldly. I took up a viewpoint that showed the best aspect of the tree and framed the image in a way that included enough of the clouds to show their billowing shape.

Enhance

The image needed just a slight increase in contrast but I felt the sky needed some further attention to emphasize it. Using the Linear Gradient tool in conjunction with the Quick Mask, I drew a graduated selection from the top of the tree to the top of the image. Using the Curves control I then increased the density and contrast of the sky area in order to make the sky a darker tone and the clouds stand out more clearly. This had the effect of making the blue sky a little too saturated so I reduced this using the Hue and Saturation sliders.

Sierra de Loja

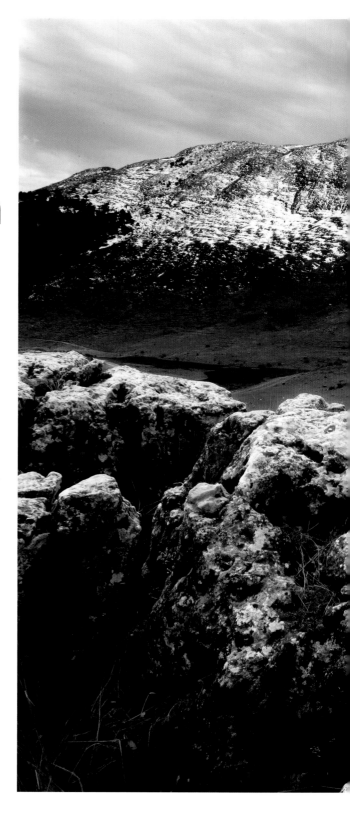

Capture

This view of the mountains south of Loja in Andalucia is from a road that I've traveled quite often over the years. It's lovely but I've never felt inspired to photograph it before. However, on this occasion it was an overcast day and the cloud had diffused the light to the extent that only very weak shadows were created and the mood was rather bleak and chilly. I found the visual link between the curious rocks and the distant snow-covered mountains quite strong and, although not immediately apparent, I felt there was a potential picture there. My first thought was to shoot the scene as an upright image, using a moderately wide-angle lens in order to make the more snowy part of the mountain fill the frame from side to side and to include some of the rocks in the foreground. This looked quite good but I decided to switch to a much wider lens and use a closer viewpoint with the camera placed horizontally. I preferred this latter viewpoint and used a small aperture to ensure sharp focus from the closest to most distant details.

Enhance

The sky was very light, almost white, which weakened the image's impact. I used the Magic Wand tool to select it and then made it darker using Curves. There was a limit to the extent I could do this before my work became apparent so I switched to the Burn tool and used this to increase the sky tone a little further.

Spectacular views do not necessarily translate into stunning photographs. Although it's understandable that places famed for their breathtaking scenery will always be popular with photographers, the chances are that the result will be disappointing. It's not always appreciated that many of the iconic pictures you see of locations like the Grand Canyon are the result of making numerous visits before finding the right conditions.

North Rim

Capture

I stayed just one night in a lodge close to the North Rim of the Grand Canyon and consequently had only one chance of a picture at sunset. I was lucky enough to have a clear sky and the sunlight was sharp and clear almost to the point when the sun set. I found this viewpoint where I was able to include a foreground of rocks with a pine tree and I used a wide-angle lens to obtain a good expanse of the distant landscape. I was quite pleased with the captured image but felt that the plain sky let it down.

Enhance

I decided to add a sky using the method described on pages 64–65. This was a sky I'd shot on the Lancashire Moors during the previous year. It had a cloud formation that seemed to fit the landscape well and the tone of the sky below the cloud was very similar to that of the Grand Canyon image. Using Curves, I adjusted the density and contrast of the sky until I felt they balanced well. I also adjusted the colour so that it matched that of the sunlit cliff face.

Yosemite

Capture

This shot was taken in the autumn in the early morning after there had been a hard frost and the atmosphere was still very cold. I was attracted by the mist rising from the surface of the small lake and by the fact that the water was so still that a near perfect reflection was created of the pine covered mountain slope rising up from the far bank. The trees were lit by sunlight but the lake was still mostly in shadow and it is this that has made the reflection quite strong. I used a long-focus lens to frame the most interesting part of the scene and used a polarizing filter to maximize the strength and colour of the reflection.

Enhance

The captured image was reasonably successful but the reflection was rather weaker than I'd anticipated. Using the Marquee tool I drew a selection of the lake surface from just below the mist and then, using a combination of Curves together with Hue and Saturation, increased the brightness, contrast and colour saturation of the reflected trees.

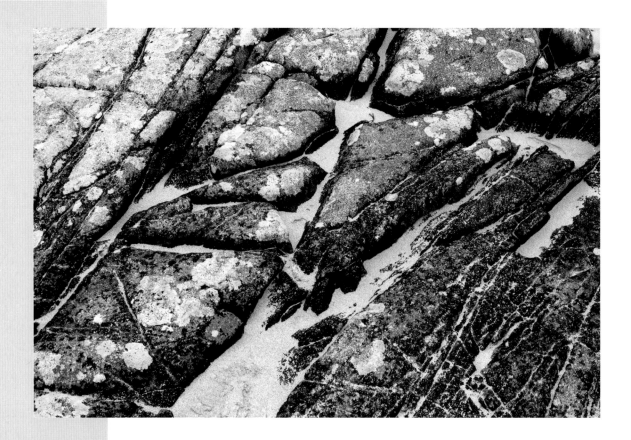

"I liked the fact that the image was almost, but not quite, monochrome"

Sandy Rocks

Capture

I came across this picture on a beach in Connemara on the west coast of Ireland. It was a beautiful expanse of silver sand, which was dotted with huge rounded rocks. I'd visited it on the previous day, a Sunday, when there was a clear blue sky and hot sunshine and although it was a pretty out-of-the-way spot it was busy with families enjoying the beach. On this day it was overcast and a cool wind was blowing and I had the place to myself. These conditions were better for most of the potential pictures I'd seen the previous day as the light was much softer and the scene lacked the dense shadows and harsher quality created by the sunlight. The wind had blown some of the sand into the crevices of the rocks and created this pattern. I liked the fact that the image was almost, but not quite, monochrome and framed the image to create a good balance of tones with the lines running diagonally across the frame.

I have a liking for images with an abstract or ambiguous quality where the viewer is not always able to immediately identify the subject. Sometimes this can be achieved simply by the way the image is framed or by the choice of viewpoint but the subject itself can have an inherently abstract quality.

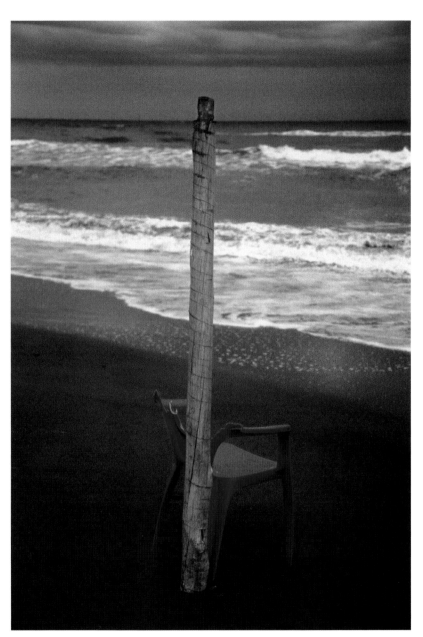

Capture

 I shot this picture in the depths of winter on Spain's Costa del Sol where the only reminders of sunnier days were the broken chair and parasol post. In the summer it would be teeming with holidaymakers but on this cold day I was the only person in sight. The sky was heavily overcast, threatening an incoming storm, and the soft light would normally have produced a very flat image. However, the contrast between the dark sky and sand and the white surf and red chair made it work for me. I had only a hand-held camera and needed to use a high-speed sensor setting to allow a fast enough shutter speed to eliminate camera shake, so there is some noise in the captured image, but I felt this contributed to the picture's mood.

The Red Chair

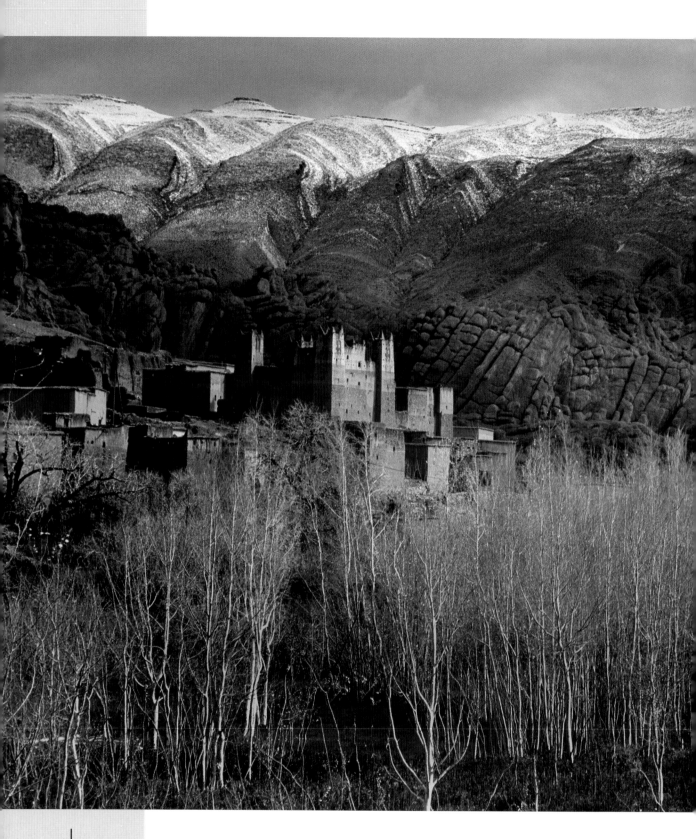

Kasbah

"Using the Dodge tool set to Highlights I brightened the area of the mountainside to the right of the buildings"

Capture

Between the Atlas Mountains and the edge of the Sahara, near the town of Quazarzate, lies the beautiful Dades valley. It's famed for the numerous kasbahs, which are strung out along the valley at the foot of the mountains. These are curiously striated and eroded and have a rich texture and in summer they contrast strongly with the fertile green fields on the valley floor. I took this picture at the end of the winter when there was still some snow on the mountain tops and the trees were still bare. I used a long-focus lens to frame this section of the landscape from a distant viewpoint, which has had the effect of compressing the perspective and making the mountains appear much close to the kasbah. I framed the shot in a way that placed the buildings to one side of the frame and included a small amount of sky and most of the trees.

Enhance

The captured image needed some after work to bring out its potential. The snow and sky were very light in tone and most of the detail here was lost, so I used the method described on page 62 to make this area darker. Instead of painting the entire darker image away on the mask except the sky I let some remain and, by using a brush with low opacity, I was also able to darken the trees a little. Using the Dodge tool set to Highlights I brightened the area of the mountainside to the right of the buildings and using Hue and Saturation I made the colour of the kasbah a little more red.

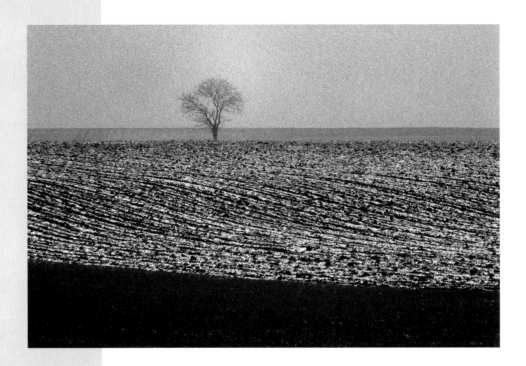

Winter Field

Capture

 In my film days I would occasionally use coarse grain to enhance the effect of an image. There were several ways of doing this but they were all partly dependent upon the image being enlarged considerably to show the grain. I used to use a much wider-angle lens than the one I'd framed the image with so the area I wanted was quite small in the frame. With image-editing software, noise can be added after the image has been down loaded and this has a very similar effect to film grain. It can be done equally easily with colour or monochrome images and its coarseness can be adjusted to a fine degree.

This shot was taken in Burgundy, France in February on a very bleak day with a heavily overcast sky and a very flat, diffused light. I used a long focus lens to isolate a small area of the scene, which has had the effect of compressing the perspective. The captured image was very low in contrast and even after adjusting levels lacked any real bite.

Enhance

I made a duplicate layer and applied about 20% Gaussian noise, in Filter>Noise, having checked the Monochrome box, and set the Blend mode to Darken. I made a duplicate layer of this layer and went to Image>Adjustments – Threshold, moving the slider until only the very darkest tones were rendered as black. Then I set the Blend mode to Darken. I next merged these two layers and made a mask and using this, I painted out the effect of the top layer on the foreground grass, which it had made too dark.

Loch Awe

Capture

I came across this scene in late October while driving along the side of Loch Awe in Scotland. I'd seen the sunset developing for a while but had been unable to find a viewpoint over the loch that had the necessary westerly outlook. Finding these remains of an old pier was very timely as the sun was beginning to weaken. I chose a viewpoint that placed the highlights on the water in the immediate foreground and, using a wide-angle lens, framed the image to include the most dramatic area of the sky. I took my exposure reading from the area of sky in the top right of the frame to avoid underexposure.

Enhance

There was a big difference in brightness between the darkest and lightest tones in the captured image resulting in a loss of detail in both shadows and highlights. To correct this I used the Gradient tool to draw a circular selection in the centre of the image using Select>Transform Selection to adjust its size and position. Using Curves I made the area outside the circle lighter and brighter and then inverted the selection to make the area in the centre of the image softer and darker.

> **"I took my exposure reading from the area of sky in the top right of the frame to avoid underexposure"**

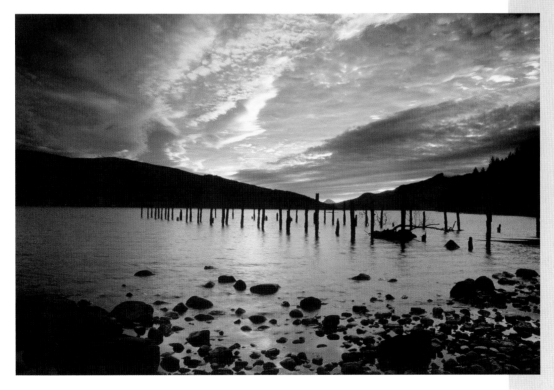

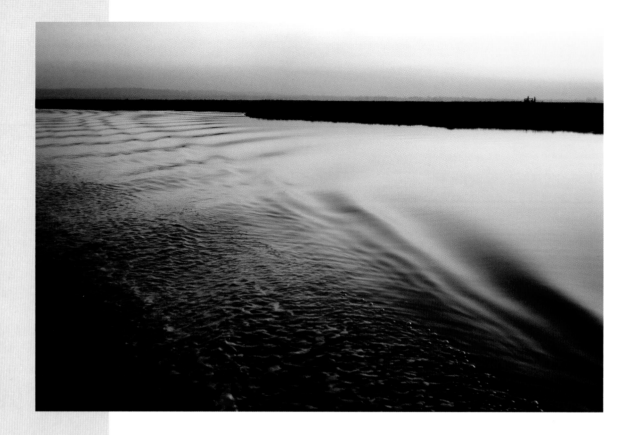

Yacht Wake

Capture

They say that sailing is like standing in a shower and tearing up twenty pound notes but I've always fancied it. Fortunately I have two friends who are very keen and sometimes take me out. On this occasion they had just bought a new boat and were keen to try it out but it was a very calm day out on the River Crouch with barely enough wind to move the yacht under sail. It was one of those sparkling winter days in January with a clear sky and bright sun and on the way back to the mooring, under power, I could see there was the chance of a picture. Because there were no clouds I knew the sunset was unlikely to be spectacular. However, the sky near the horizon had turned to this magenta hue when the sun had dipped below the horizon and I became aware that the picture was really of the rippled wake and its reflections rather than in the sky. I used a wide-angle lens to frame as much of the water as possible and enough of the sky to show the colour change from magenta to blue.

Capture

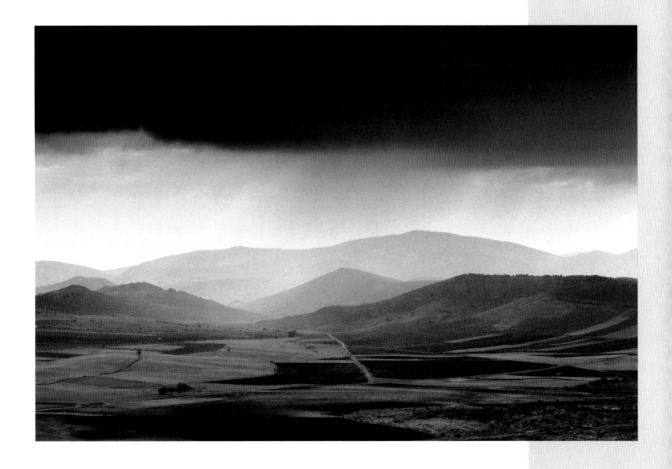

This shot was taken in the Spanish region of La Mancha from the hilltop village of Atienza, where a rough track leads up to the remains of a castle. I have a rule of thumb in Spain, if you want a good view look for a castle, as they picked all the best spots to build them. It had been an overcast day with thick cloud and some outbreaks of rain but as evening approached the sky began to clear. I liked the way the slight amount of mist in the atmosphere had created a degree of aerial perspective giving the distant mountains a receding effect. I also liked how the brighter sky had illuminated the patchwork of fields enough to lift the contrast and give the image some bite. I used a long-focus lens to frame the most striking area of the scene and after down loading used the Gradient tool to make the sky a little darker.

Spanish Storm

Dartmoor

Capture

I'm sure I'm not alone among landscape photographers in being drawn to rock formations. There is a sculptured feeling about rocks that seems to suggest the work of a powerful pair of hands. Dartmoor is renowned for its tors and some of them are huge and very impressive but this group of stones was relatively small. My interest was roused by the fact that they were being very nicely lit by the soft evening sunlight with both their form and texture being strikingly enhanced. I chose a close viewpoint and used a wide-angle lens in order to create a sense of depth. I then framed the shot in a way that placed the nearest rocks along the right edge of the frame and the more dominant shapes of the mid-ground rocks in the centre. I felt this created a good balance with the smaller boulders leading out of the frame on the left.

Enhance

The evening sky was cloudless and rather bland, but I'd been obliged to include a large area of it in order to frame the rocks and I felt it detracted from the picture. The outline of the rocks was clear-cut and I was able to select the sky, invert the selection and copy the rocks. I then simply pasted this copy onto a sky that I thought would work. In retrospect I think I could have found a more suitable sky and at some point will try the image again as I think this one is just a bit too colourful.

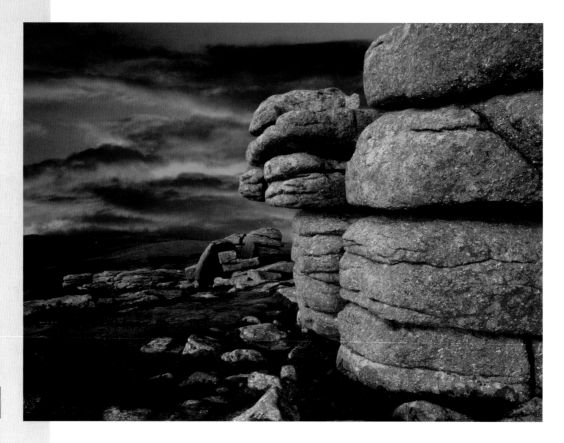

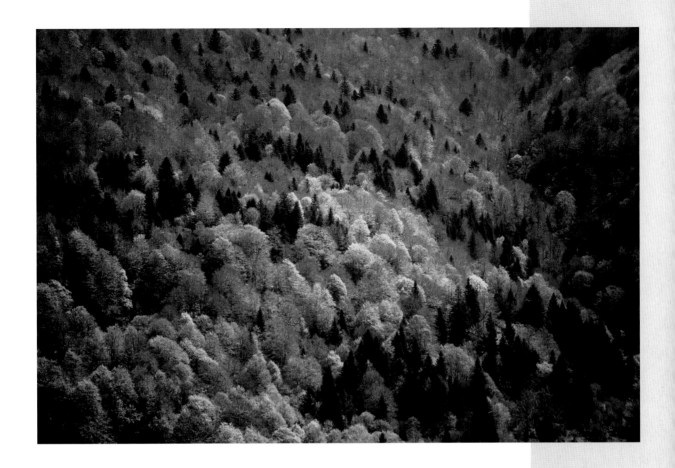

Valleé de la Jordanne

Capture

The Auvergne is one of my favourite regions in France and this particular valley, near the peak of Puy Mary, is simply stunning. This shot was taken in the spring when the leaves were just beginning to form and in another week or so the whole valley slope would have been uniformly green. But this pattern of fresh bright green and the grey tint of the bare trees and the dark firs caught my eye. I used a long-focus lens to isolate a small area of the mountainside and framed the shot so that the brightest area of green was placed more or less on the intersection of thirds.

"I framed the shot so that the brightest area of green was placed more or less on the intersection of thirds"

Yellow Weed

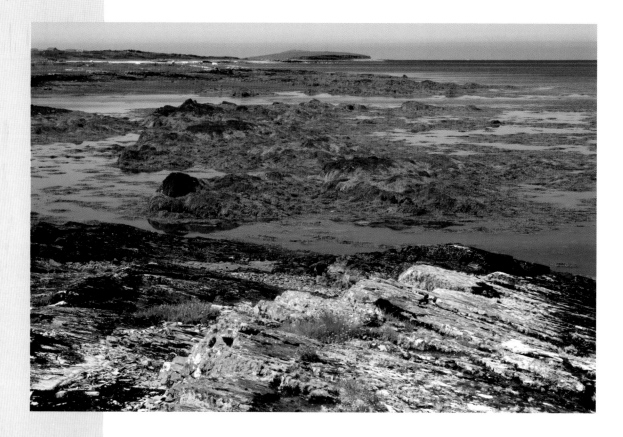

"I often think how picture taking opportunities are so fleetingly transient"

Capture

I often think how picture taking opportunities are so fleetingly transient, especially with landscape photography, and how frequently a picture would have been missed had I passed by the same spot a little earlier or later. I saw this picture while driving along the west coast of Ireland. The obvious attraction was the bright orange seaweed but I also liked the lichen covered rock and the distant grassy headland. I used a wide-angle lens with a close viewpoint to create a strong foreground as well as including a wide expanse of the scene. I framed the image so that only a small area of the rather blank and uninteresting sky was included. I passed by this scene a number of times afterwards and either the tide was too far out, too far in, or the light was too flat and the sea was too rough.

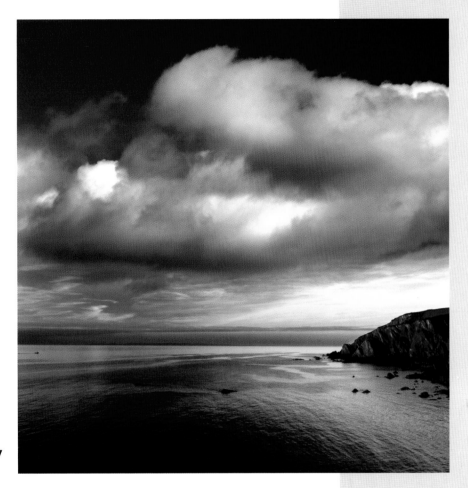

Lee Bay

Capture

 This small bay is in North Devon not far from the famous surfing beach of Woolacombe. I took the shot late on a summer's evening when the setting sun was illuminating the headland. The tide was high, the sea a flat calm and the mood one of blissful tranquility. These things are difficult, if not impossible, to capture in a photograph but I could not resist an attempt. There were a few houses on the headland and I wanted to exclude them in order to preserve the tranquil atmosphere. This placed the headland very close to the right edge of the frame and using a wide-angle lens I used a wide expanse of the sea as a balancing element.

Enhance

 I was quite pleased with the resulting image and it did have the peaceful feel I wanted but I felt it lacked impact. The sky on the captured image had some soft clouds but seemed to lack something. Normally when adding a sky I try to find one that is compatible with the host image, not necessarily to deceive but so as to not draw undue attention to it. But in this case I decided to use a sky, which was unashamedly dramatic and added it using the method described on pages 64-65.

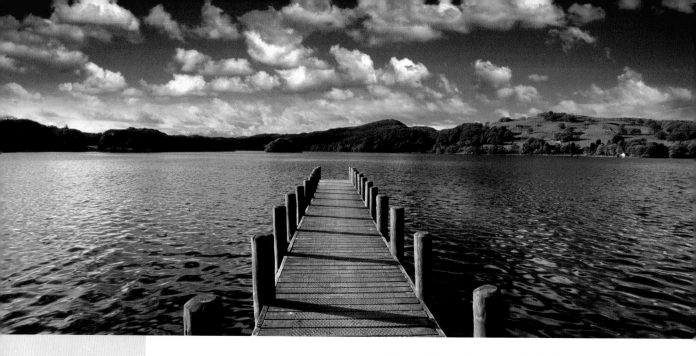

One of the things I like about the digital process and the demise of the colour transparency is that I'm no longer a slave to the predetermined formats dictated by the camera. Previously the choice was rectangular, square or panoramic. Admittedly, darkroom workers could crop their prints to a different shape but there was not much you could do to alter that of a colour transparency.

Lake Coniston

Capture

I discovered this viewpoint early one October morning while driving along the southern shore of Lake Coniston in England's Lake District. The sun was still low in the sky and created some nice shadows and texture. I chose a viewpoint that enabled me to use the jetty as a foreground and, using a wide-angle lens, I framed the image so that it was in the centre of the frame. I used a polarizing filter to increase the image's colour saturation and to subdue some of the highlights on the water.

Enhance

The captured image was quite pleasing but needed some after work to bring out the best it could offer. The water on the left of the jetty was much brighter than that on the right and the highlights were almost burned out. I used the Burn and Dodge tools to make them more even. Although there was some cloud close to the horizon in the captured image it was a bit untidy and not very interesting so I decided to add some clouds from another picture, which I did by using the method described on pages 64-65.

The Devil's Golf Course

"I was able to alter the sky's density and contrast without my work becoming evident"

Capture

Anyone who plays golf will know how well this area of Death Valley in California has been named. It's a strange thing, but I've been to Death Valley three times now and, in spite of it being one of the hottest and driest areas in the USA, it's been cloudy every time. Once it actually rained. However, this is not a bad thing as plain blue skies can have a very negative effect on landscape images and well-formed or textured clouds can be a real bonus. I chose a low viewpoint that allowed me to use a particularly rough area of the terrain as a close foreground and I used a wide-angle lens to frame a wide expanse of the scene.

Enhance

The sky was promising but too light in tone and there was too much of it so I first cropped the excess sky from the top of the frame. With a little care and patience I was able to select the remaining sky area using the Magic Wand tool, adjusting the degree of contraction and expansion and adding a small amount of feathering until I was able to alter its density and contrast without my work becoming evident.

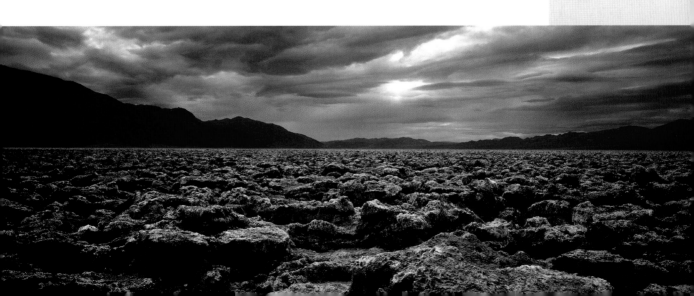

Boulders

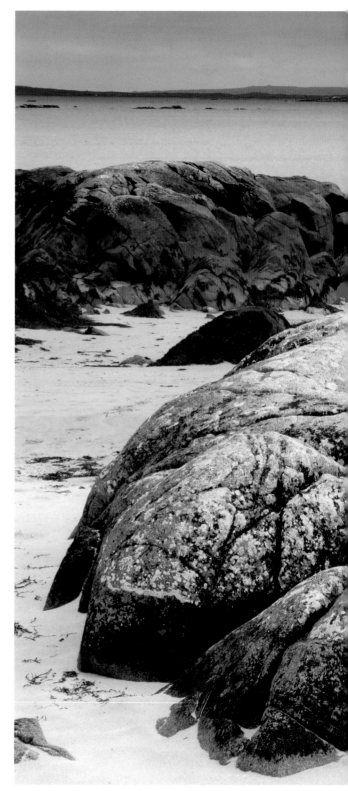

Capture

 I discovered this beach while exploring the coastline of Connemara on the west coast of Ireland. I consider myself to be something of a beach connoisseur — I'm probably a frustrated beachcomber at heart — and I rate this one as one of my top ten favourite beaches. My first visit there was on a sunny day and I took a number of photographs that worked out quite well. But I was aware that many of the shots I would have liked to take would not have worked because there was too much contrast. The sunlight was very clear and sharp and there was a cloudless sky, which resulted in dense black shadows and harshly bright highlights. The plus side was that the sea was the most incredibly translucent turquoise.

On this visit the sky was overcast and the light very diffused which has resulted in the sea and sky having little or no colour. I felt this was an acceptable trade off for the softer light and even thought that a strong colour at the top of the frame might well have detracted from the extraordinary shapes and textures of the rocks. I chose a viewpoint that placed this group of nicely shaped grey rocks in the immediate foreground with the brown rocks visible behind. I framed the image to allow a little space at the left edge of the frame and to include the small distant group of rocks on the right. I set a small aperture to ensure maximum depth of field.

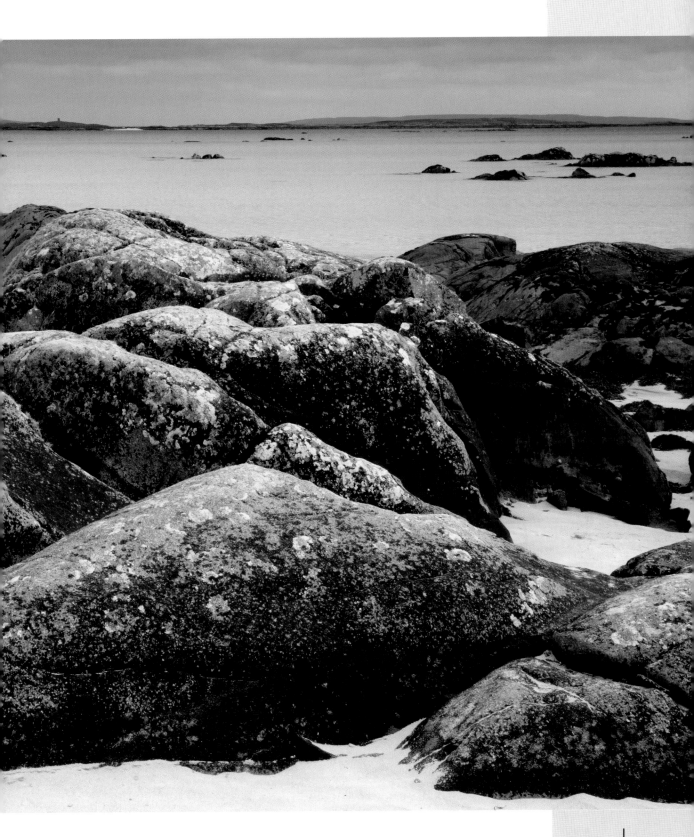

Capture

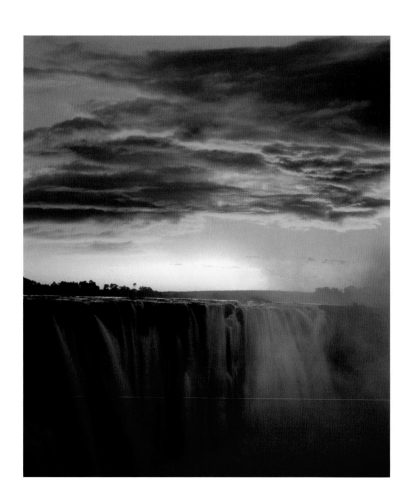

I am very attracted to waterfalls and jumped at the chance to see Victoria Falls in Zimbabwe. In normal circumstances with a location like this I like to try to visit it at least twice, ideally in the early morning and late afternoon. On this occasion my only chance was in the morning so I made the effort to be there by sunrise. It is a truly stunning sight and you can hear the roar of water from a great distance away. I arrived a short while after sunrise but before the sun has risen above the horizon and the light was beautiful. I knew that I had to take my shots before the sun appeared otherwise I would be shooting directly into it. I'd found a viewpoint that gave me a good angle on the wall of water but far enough away to avoid the torrent of rain-like mist being sprayed out, even on a calm day. The sky was clear apart from a few wispy clouds just above the horizon so I framed the image to include only a small area of it.

Enhance

The captured image was fairly successful but all of the interest was focused on the water and I felt the picture needed some balance from the sky. I had a sky on file which was of a cloud formation lit from below by a setting sun and I thought this would work well with the waterfall image so added it using the method described on pages 64–65.

Victoria Falls

> **"All of the interest was focused on the water and I felt the picture needed some balance from the sky so I added one from my collection"**

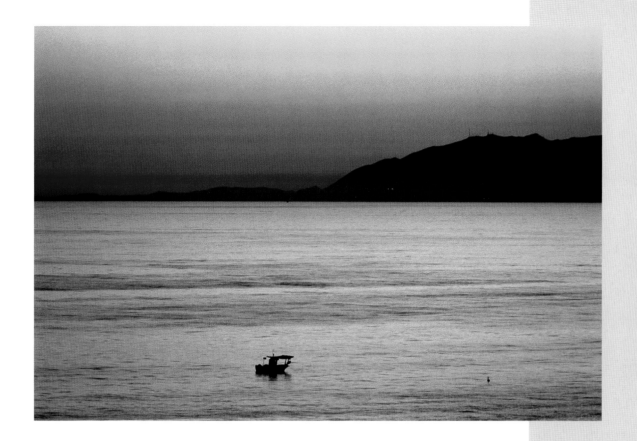

Costa del Sol

Capture

 This shot was taken from the roof terrace of an apartment block overlooking the sea near the small fishing port of La Caleta de Velez. It's a viewpoint I've used quite often although it is astonishing just how much variety there is among the images I've produced. I used a long focus lens to enlarge a small area of the scene and framed the shot to exclude some buildings just below the bottom of the frame. This placed the boat rather lower in the composition than I would have liked but I didn't feel it detracted too much from the overall effect. It was in reality a lot darker than it seems here, the sun had set some time ago and I needed an exposure of about one second. Although the sea was very calm the boat was moving a little some of the time and I made a few exposures to ensure that I had one that was perfectly sharp.

The Bog Road

Capture

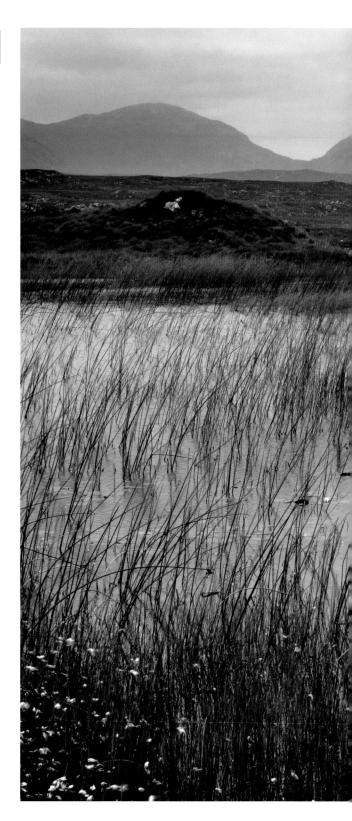

I think it's very hard to please photographers as far as weather is concerned. One minute I'm complaining about blue skies in Utah and the next I'm moaning about clouds in Ireland. This shot was taken as I crossed the Bog Road in Connemara on the sort of day you'd associate with bog land, with drizzle and an overcast sky. The presence of water has added an essential degree of contrast and I chose a viewpoint and framed the image to make the most of this feature. However, the captured image was still rather too flat even after I'd adjusted the levels.

Enhance

I made some adjustments to the tones in the image by working with a duplicate layer in the way described on pages 62–63. In addition to making the sky darker I also used the ability to paint away areas using the mask to add some brighter and darker tones to other areas of the picture as well as using the Dodge and Burn tools.

"The presence of water added an essential degree of contrast and I framed the image to make the most of this"

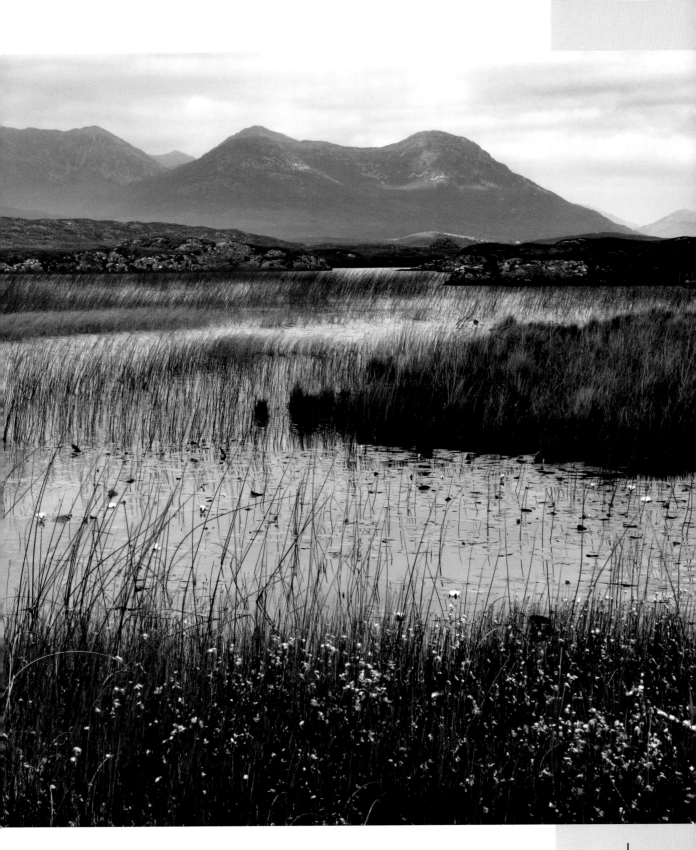

I've seen many things while searching for pictures that, although outstanding in some way, simply would not make a good photograph. One situation, which crops up fairly frequently in my case, is that of a dramatic sky or cloud formation and not being able to find anything of enough interest to provide a foreground.

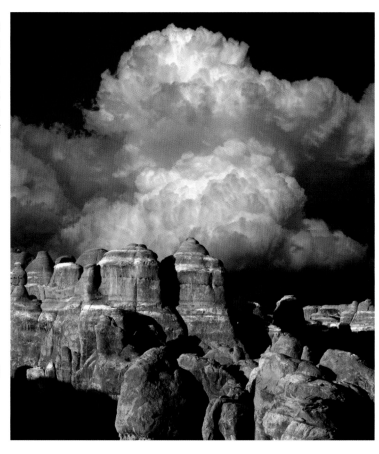

Maestrazgo Cloud

Capture

 There seem to be certain places that encourage the formation of dramatic clouds. One such area where I've seen some stunning formations is a region in Spain called the Maestrazgo. It's a wild and unspoilt area and I always try to take a detour there if I'm nearby. On this occasion I saw a magnificent cloud forming with a beautiful mountainous shape and gloriously fluffy texture. I searched for some foreground interest that I could combine with it but was unable to find anything worthwhile. I decided to shoot the cloud anyway and went to a high point so that I could have a clear horizon.

Enhance

 I made a trip to Utah in the USA a while ago and was 'blessed' with a spell of cloudless blue skies. It was wonderful from the holiday point of view but after a while it became a bit monotonous photographically. This shot of the rock formations was taken on one of those days in the national park of Arches in the late afternoon when the shadows were getting longer and the light was creating some strong shapes and textures. Because the sky was such a dense blue it was relatively easy to select it using the Magic Wand tool. I then inverted the selection and copied the rocks in order to paste this onto the cloud image. When performing a technique like this, it is often necessary to adjust the degree of expansion and contraction of the selection and to use a small amount of feathering. It's also sometimes necessary to go to Layer>Matting - Defringe to remove any hint of an edge around the pasted layer.

Capture

 There is a very attractive pocket of countryside around the town of Alhama de Granada in southern Spain. I visit this area whenever I get the chance, as I always seem to find a picture or two there. I took this shot in late autumn after the grain had been harvested and some of the fields of stubble had been burnt. It was late in the day and the sun was very low in the sky creating this rich texture and emphasizing the undulating contours of the land. I used a long-focus lens to isolate a small section of the landscape and framed the image so the burnt field occupied the bottom left corner of the frame and the dominant line, where there was a track, more or less bisected the image.

> **"The sun was very low in the sky creating this rich texture and emphasizing the undulating contours of the land"**

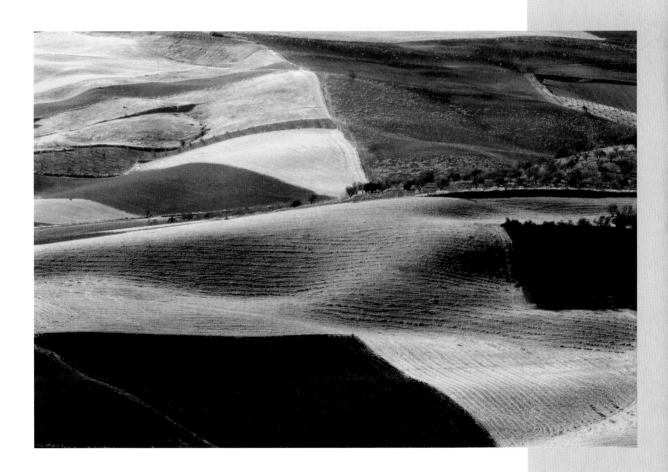

Andalucian Fields

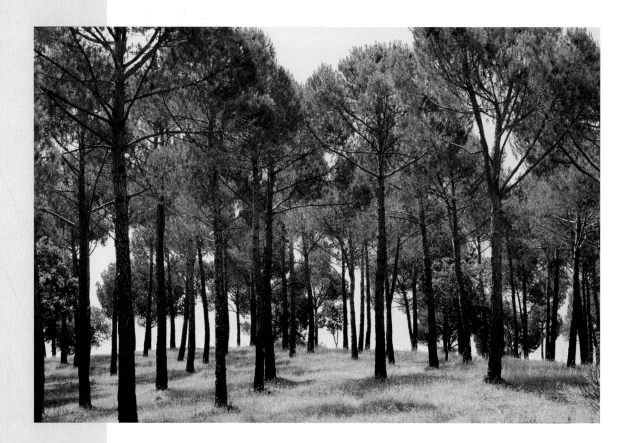

Spanish Pines

"The sunlight was at just about the perfect angle to light the foliage"

Capture

I think it's fair to say that everyone who does something creative develops a repertoire, either of subject matter or of techniques, and then tends to spend much of their time reworking the same themes. It's certainly true as far as I'm concerned and I'm aware of a number of images that I take time and time again in different guises. This is one of them. I find something very appealing about trees when they are planted, or have grown, in an orderly way. This particular scene made me want to photograph it because the sunlight was at just about the perfect angle to light the foliage and to make a strong pattern from the tree trunks. I also liked the simple colour scheme of gold, green and pale blue. I chose a viewpoint that created the best spacing and separation I could manage between the trees. I framed the image so the one complete tree that could be seen clearly was placed along a line that divided the image into thirds.

The Water Pocket Fold

Capture

 This rather extraordinary landscape lies within Utah's Capitol Reef National Park in the USA. Of all the national parks I've visited in the south west of the country this is the one I like best, although it is one of the least visited. I shot this picture in the late afternoon when the sun was at an acute enough angle to create some strong textures and contours. I used a long-focus lens to enlarge this small section of the distant view and framed the shot to crop just below the base of the slope and to include a little of the plain blue sky. I used a polarizing filter to increase the colour saturation and to improve the clarity of a slightly hazy atmosphere.

Enhance

 Although I was quite pleased with the shot, and the landscape was very striking, I thought that, as an image, it would have more impact if there were a more interesting sky. I was able to select the sky using the Magic Wand tool and inverted this to copy the landscape, which I then pasted onto a suitable sky from my collection.

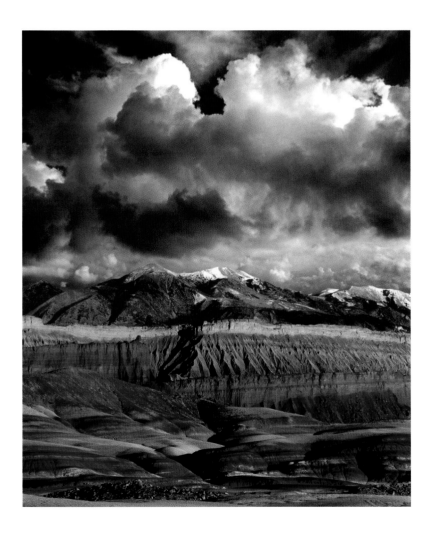

"After the sun had disappeared I could see that some quite striking colour was developing in the sky"

I'm sure that, like me, many photographers have favourite locations, places they will return to time and again. This beach is a place where I've spent a considerable amount of time largely because I go there on holiday with no real intention of taking any serious photographs. However, after a while something will stir me into action and I'll wander down to the beach and take a few photographs. Even in my laziest mode it's unlikely I'll return home without some new pictures taken on the beach and it's surprising how varied they can be.

Capture

I'd watched the sun set from a terrace overlooking the beach and had been prepared to simply let it be a nice memory. But after the sun had disappeared I could see that some quite striking colour was developing in the sky. I grabbed my camera and tripod and hurried down to the shore and made a number of exposures while the light was still quite bright. I was on the point of giving up when I could see that, now it was almost dark, the colour had intensified further. Using a wide-angle lens I chose a viewpoint that allowed me to fill the foreground with the incoming waves, as it was only the light it was reflecting from the sky that made the water visible. I framed the image to include a little of the distant headland on the right.

Sea and Sunset

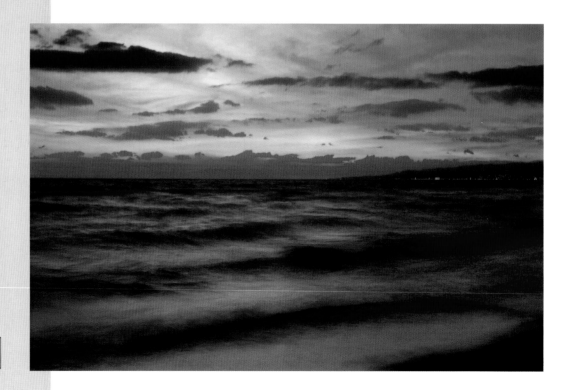

Capture

The early morning light can be glorious in the summer and when the water is as still as this it becomes a very attractive sight. In these conditions a few small fishing boats cruise close to the shore to dredge the sand for clams. I was, in fact set up to take a rather abstract shot of just the buoys and water when I saw this boat approaching and thought that it might finish up in the right spot for a shot. I chose a viewpoint which made a zig zag of the buoys and framed the image so there was some space to each side of them and just a small amount of the clear blue sky. Then I simply waited until the boat reached the right spot before making my exposure.

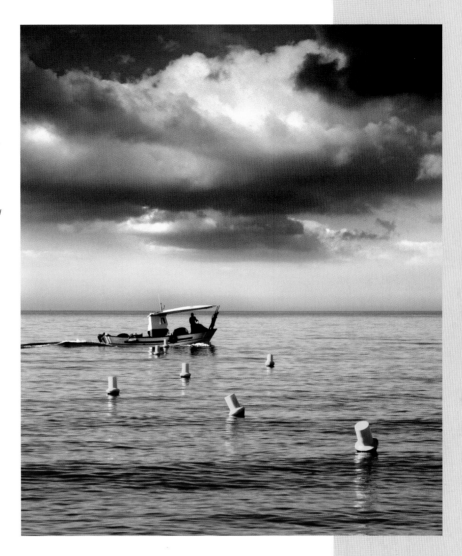

Boat and Bouys

Enhance

Although I was quite pleased with the captured image I felt that it lacked impact and needed the addition of an interesting sky. I chose one from my collection that I felt was compatible and added it using the method described on pages 64-65. My choice was not based on an attempt to deceive the viewer into believing that this was how the scene had actually looked, because it doesn't take long to see that the lighting on the cloud is quite different. I simply wanted to add an element to the composition that would make the picture more interesting.

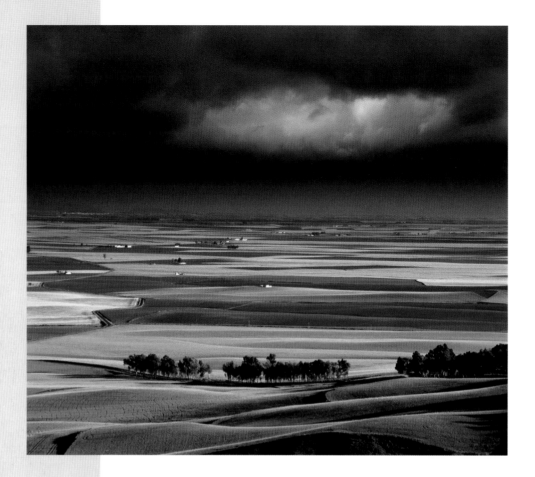

Carmona View

Capture

The walled hilltop town of Carmona near Seville in Andalucia has a splendid castle that not only has the usual superb view but is also a Parador hotel. This convenient fact makes it a fairly painless task to shoot pictures very early or late in the day. This shot was taken shortly before sunset on a summer evening when the sky had begun to clear after a storm. Consequently the atmosphere was very clear and the sun had lost little of its power as it approached the horizon. I'd looked at this viewpoint a number of times before but when the sun was higher and the sky was plain blue there was no picture worth having. It is the low glancing angle of the sunlight and the rich texture it has created that has made the view into a potential photograph. I used a long focus lens to select the most interesting area of the scene and to compress the perspective. I framed the shot to include the contours in the foreground and the line of trees as well as a large area of sky to create balance.

Capture

 A friend told me about Mono Lake when he heard I was making a trip to the south west of the USA. He told me it was well worth a visit and the best time to shoot was either very early or late in the day. I planned to take my shots in the evening and timed my journey to arrive about an hour or two before sunset. I was lucky to find a road down to the southern side of the lakeshore quite quickly. However, time was short as my planning had not allowed for the fact that a mountain range to the west meant that the sun would disappear an hour or so earlier than the official sunset. Because of this I had to look for viewpoints in something of a hurry, as I wanted the outcrops of tufa rock to be sunlit. This was the best of the viewpoints I found and I was lucky that the lake was quite calm with only a few ripples to disturb the water leaving a good strong reflection. I framed the image to include almost all of the rock formation and cropped out the excess sky and foreground to maximize the impact of the textured stone. I used a polarizing filter to increase the image's colour saturation and to strengthen the reflection.

> **"I framed the image to include almost all of the rock formation and cropped out the excess sky and foreground to maximize the impact of the textured stone"**

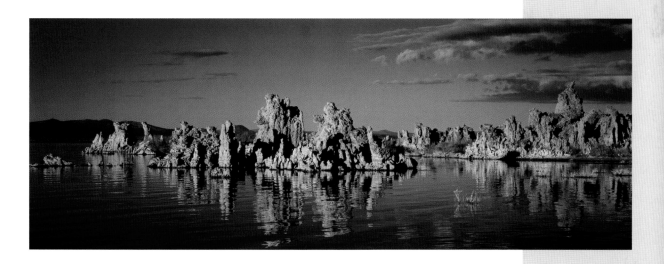

Mono Lake

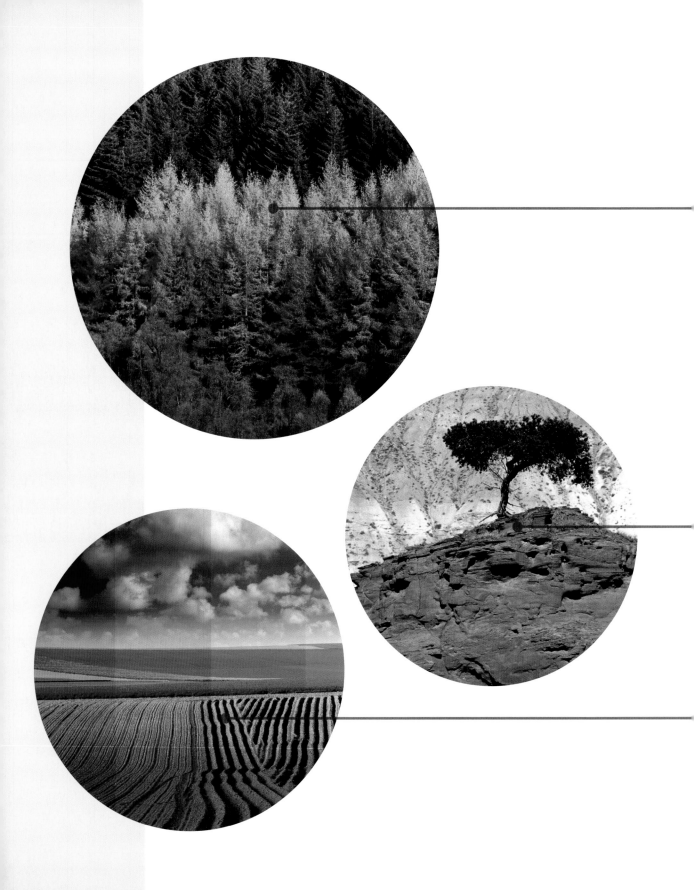

cameras and equipment

sensors and pixels

It's easy to become a bit confused about sensors and pixels as well as some of the other new digital terms when you're new to digital photography because the terminology is so unfamiliar.

In a digital camera the image is captured on a sensor that records it electronically as a series of minute dots of light. In fact this is not very different to the way film records an image on the individual grains of silver halide in the emulsion. This is the easiest way to understand the process because an image that consists of a greater number of pixels means they are proportionately smaller pixels producing a higher quality image with the potential to be enlarged to a greater degree, just like a very fine grain film.

One of the most important things that defines the potential image quality of a digital camera is the number of pixels the sensor can record. To make a good quality print from a digital file requires

Fishing boat photographed on a 17 megapixel SLR on the west coast of Ireland

"Increasing the size of an image is likely to involve some degradation of the image"

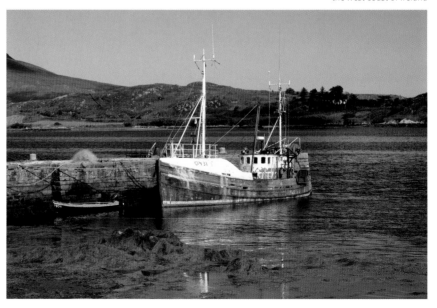

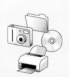

A small section of a 16 x 12 ins image printed at 300 pixels per inch from a 47.5 Megabyte file.

The above image llustrates the effect of interpolating a 3 Megabyte file to produce a print of the same size at 300 pixels per inch.

the image to contain 300 pixels per inch. This means that to make a 10 × 8 inch print you need to have 2,400 × 3,000 pixels, which is a total of 7,200,000 or – as the jargon has it - just over 7 mega pixels. There are other factors that determine image quality, such as the size of the sensor and the camera's optics. A camera that balances all of these elements well will create a better quality image than a camera with a greater number of pixels but that is lacking in the other aspects.

A process called interpolation can increase file sizes artificially. If you check the Resample box in Image>Image Size and then enter the size you want the image to be the computer will manufacture the extra pixels needed. The success of this process depends on a number of factors, such as the degree by which you wish to increase the image size, the inherent quality of the captured image, how it was stored and the nature of the subject.

I have successfully interpolated an image from 18 to 50 megabytes with no visible loss of quality on some occasions. However, with a different subject, sometimes the shortcomings of this technique have become only too apparent.

Bear in mind that, after downloading, small files will open more quickly, which can save editing time, while applying a filter to a big file can be very time consuming. Another factor to consider when choosing file sizes is when working with layers because a 50-megabyte file can quickly escalate to several hundred megabytes when several layers are involved. On the other hand, a big file can be reduced in size very easily, without loss of image quality, whereas increasing the size of an image is likely to involve some degradation of the image.

digital cameras

The digital compact camera is often most people's first step into digital photography and they do offer good value, although they are more expensive than a similar film camera.

Most of these compact cameras will have both an optical viewfinder similar to a film camera and the ability to view the subject on a screen at the back. It is important to appreciate that the image seen though the optical viewfinder is not identical to that being captured, This is something that can be a problem when shooting close-ups but which can be overcome by viewing the subject in the rear screen. Many digital camera users prefer to use this method of composing and shooting their pictures but it is much more likely to produce camera shake than holding the camera firmly to the eye.

Most of these entry-level cameras will be fitted with a fixed lens, usually with a modest zoom range of 3 or 4 to 1, which is the film camera equivalent of 35mm to 105mm or 140 mm. They will often have both an optical and a digital zoom and these are sometimes added together in the camera's specifications. The optical zoom is achieved by altering the focal length of the lens but the digital zoom is the result of enlarging the image by interpolation and is little different to cropping and enlarging the captured image at the editing stage. Depending upon the number of pixels offered cameras of this type are capable of producing a

This image was shot on a 6 Megapixel compact camera no bigger than a packet of cigarettes and can produce an excellent quality print up to A4.

"One of the biggest advantages of the SLR is the ability to change lenses"

good quality print from about 6 x 4 inches up to A3 or even more.

Another feature to be considered when choosing a camera is the provision of shooting modes. Auto or program means that the camera sets the combination of shutter speed and aperture according to the lighting conditions. This allows little creative control and to achieve this you need a camera that offers either manual settings or aperture/shutter speed priority.

A further consideration is the sensor speed options, which are indicated in terms of ISO film speeds, and can be from ISO 100 or 160 up to ISO 3200 or higher. Each doubling of the speed, from ISO 160 to ISO 320 for instance, is equal to using a one-stop wider aperture, or a one-stop slower shutter speed, and provides more options when shooting in low light levels. There is a cost, however, when using higher speed settings as it increases the noise level – the background interference recorded by the sensor – which has a similar appearance to that of film grain.

The method of storing the captured image is yet another factor to be taken into account. This can be either CF or Compact Flash cards, SD or Secure Digital Cards, Smart Media Cards, or XD Picture Cards and will depend upon the camera's design and specification.

The choice of most professional photographers is a SLR digital camera. These offer a significantly higher build quality together with interchangeable lenses and also the facility of viewing the image through the camera lens, thereby showing exactly what is being recorded. The SLR digital camera offers a wider range of sensor speeds and shooting modes as well as more accurate exposure control and faster focussing. There will usually be a choice of storage formats often providing the facility to record in RAW mode as well as TIFF or JPEG.

One of the biggest advantages of the SLR is the ability to change lenses. Although the fixed zoom on simpler cameras provides the most frequently used focal lengths they do not allow the use of ultra wide angle, very long focus lenses or specialist optics such as shift and macro lenses. Although Digital SLRs are very similar in size and appearance to 35mm film SLRs many of them have sensors that do not fill the 35mm frame and consequently the angle of view produced by a given lens is not the same. In most cases the focal length of a given lens is increased by about 1.4 so a 20 mm wide angle becomes only a 28 mm.

I used a high resolution Professional SLR for this shot in order to capture the fine detail of the foliage. It will produce a high quality print in excess of A3.

lenses and accessories

The majority of digital cameras have a mid-range zoom as a standard lens, whether the camera is a simple compact or an interchangeable lens SLR. This will cover the needs of a large proportion of the photographs you are likely to take.

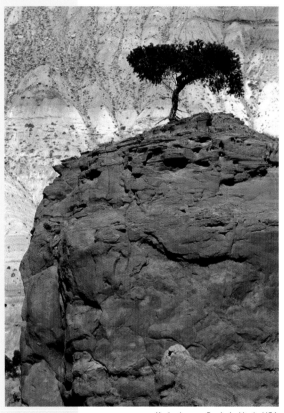

Kodachrome Basin in Utah, USA.
I used a 300 mm lens with an SLR camera
to isolate a small area of the scene.

However, the serious or more specialised photographer, who will be using an interchangeable lens camera, may well find it desirable to invest in one or more additional lenses. For example, landscape photographers will find an ultra wide-angle lens invaluable on occasions, as will those who shoot architectural subjects and reportage, while wildlife and sports photographers will often require the use of a long-focus lens.

Using very wide angle and long focus lenses also allows a photographer to have more control over the perspective of his or her images. A wide-angle lens, for instance, enables you to include both close foreground details and distant objects. This exaggerates the impression of perspective making distances appear greater and giving an image a greater sense of depth. A very long focus lens not only enables you to take close up photographs of distant subjects but can also be used to compress the perspective of an image and produces pictures with a more two dimensional, graphic quality.

While many mid-range zoom lenses will have a close focussing facility a macro lens is the ideal optic for close up photography, because they allow

very small subjects to be photographed at life size. For this type of work bellows units or extension tubes are also essential accessories.

Filters

The ability to edit an image extensively after capture means that filters, which were previously an essential accessory for those using colour film, are now largely redundant. Using a warm up filter, for instance, was often essential when shooting landscapes using colour transparency film. However, with a digital image it is a simple matter to make adjustments like this on the computer after the photograph has been taken, and therefore much more accurate and controllable. Even the effects of a graduated filter can be created much more easily and precisely with programs like Photoshop. The use of an orange

These two pictures show the difference a polarizing filter can make by reducing the amount of light reflected from the sky, water and foliage and increasing the image's colour saturation.

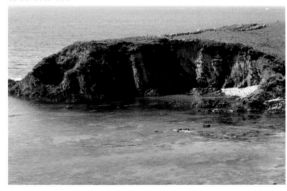

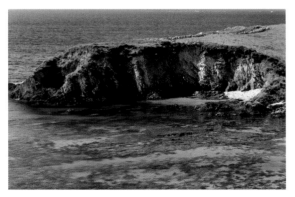

filter, for example, to darken the sky when shooting in black and white appears so crude and limiting compared to the use of the channel mixer.

I now find that I can dispense with most of the large collection of filters I used to carry in my bag along with my rolls of film, but with one important exception, the polarizing filter. This filter has the effect of eliminating or reducing the light being reflected from non-metallic surfaces, which includes the water droplets that create blue sky and foliage. Using the polarizing filter has the effect of increasing the colour saturation of a scene and the result is very different to the overall increase in colour saturation which can be made when image editing.

Flash

Many cameras are equipped with an integral flash unit. Although this is useful for shooting casual snap shots in poor light it has considerable limitations for more serious photography. This is partly due to the relatively low power which most of them provide but also the fact that the flash is fixed in position close to the lens. A separate flashgun allows the light to be directed from a position away from the camera and for it to be diffused or reflected creating much more effective lighting and better image quality.

The best results from on camera flash will be obtained when it is used to supplement the ambient light or when the subject is quite close to the background. This will avoid shots of people who look as though they are suspended in a black void. Using on camera flash can also be an effective way of reducing contrast when shooting pictures in harsh sunlight when there are both bright highlights and dense shadows. Using the flash in fill-in mode will allow the correct exposure for the highlights while the flash illuminates the shadows.

making prints

For the majority of amateur photographers the main purpose of taking a photograph is to have a print of it. Making your own prints has never been easier and the cost of a printer that is capable of producing a high quality result is constantly reducing.

Whatever type and size of printer you decide to buy the main concern is that the finished print matches the image on your monitor as closely as possible in terms of colour balance, density and contrast. A perfect match can never be possible because the image on the screen is formed by transmitted red, green and blue light, while the image on the print is viewed by light reflected by cyan, magenta, yellow and black inks. However, for most needs a very adequate match can usually be achieved fairly easily and even an inexpensive printer these days will produce a surprisingly good match straight from the box.

The process of adjusting the print settings so the output matches the image on the monitor is known as profiling and this can be done professionally. It involves making a test print using your chosen brand and type of paper from a control image supplied by the profiler who then provides the settings necessary to obtain a match. Many of the ink and paper suppliers now offer this service.

If you intend to calibrate your printer yourself, it's important that your monitor is correctly adjusted according to the manufacturer's instructions before you begin and that you view the print under the

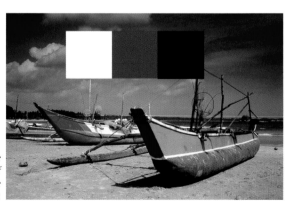

A control image made by using the marquee selection tool to add panels of black, 50% grey and white to an image with a good range of colours.

correct lighting conditions. Daylight, or a daylight matching fluorescent tube, is suitable but a print viewed by normal domestic lighting will seem much more red than it really is. It's also important that when adjusting the image on the monitor it is screened from room or window lighting, I prefer to work in a darkened room. If you use more than one type of paper, or buy a new set of inks, you may find it necessary to make further adjustments to the print settings but my experience has been that there is much less variation in the recent materials.

Even when your printer settings have been correctly adjusted, I think it's still best to make a small test print. The darkroom method is to make a test strip with several different exposures on one piece of paper and this is easy to do on the computer. Using the Marquee Selection tool you can draw a

sequence of strips across a representative part of the image and alter the density of each by about 20% or so, making a note of the different settings. You can also apply this method to the colour balance and the contrast if you wish.

Your image should be sized at 300 pixels per inch although you may find there is little noticeable difference in 250 or even less when using textured papers, such as linen or canvas.

> **"It's important that when adjusting the image on the monitor it is screened from room or window lighting"**

A test strip made by using the marquee selection tool to select five sections of the image in turn and increasing and decreasing the brightness by a factor of 10 each time.

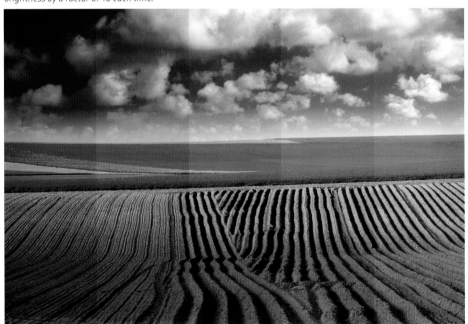

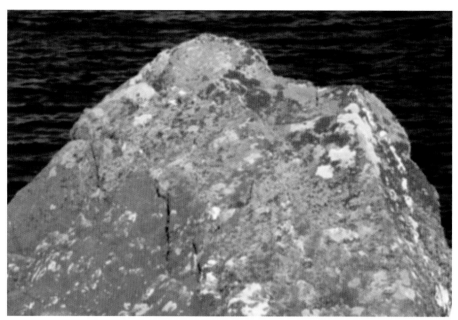

Original image

"It is usually necessary to sharpen the image before printing and the best way to do this is to use Unsharp Mask"

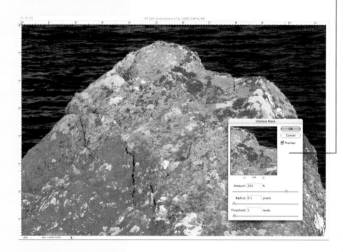

It is usually necessary to sharpen the image before printing and the best way to do this is to use Unsharp Mask found in Filter>Sharpen. There are three sliders: one controls the amount of sharpening, another the radius and the third the threshold. It's important to view the effect of sharpening with the monitor image set at either 25%, 50% or 100% because in between settings give a misleading indication of the effect. Each image will require a different setting depending upon the image size, the file size and the nature of the subject. Because of this it's best not to apply unsharp masking until you are ready to print. As a rough guide, with an A4 print at 300 pixels per inch and a file size of about 25 megabytes, I find something in the region of 200% with radius .5 and threshold set to 5 is effective with most subjects. Over sharpening will tend to create pixelation especially in areas where the image has been extensively manipulated.

*Final image as sharpened using the Unsharp
Mask feature. Amount set to 200%, radius to
.5 pixels and threshold set to 5 levels.*

Ink Jet Printers

The ink jet or bubble jet printer is the most widely
used method of making photo quality prints from
digital files and is capable of superb results. Printers
vary hugely in price, depending upon the paper size
they will handle, ranging from A4 to A0, and the
inks they use. There are four basic ink colours: cyan,
magenta, yellow and black but many machines
include more colours with both normal magenta
and cyan and also light versions of the same
colours, for example.

With some printers it is necessary to replace an
entire single four-colour cartridge when one of
the inks runs out but other printers allow you to
replace a single colour cartridge. It is also possible
to buy ink sets that are dedicated for use with
monochrome images because colour inks can result
in impure greys.

Printers either use dye-based inks or pigment inks.
The former tend to produce slightly more vivid
colours while the latter have better archival qualities
with prints remaining fade free for up to 100 years
or more. Ink jet printers are able to print on a wide
variety of papers ranging from glossy photo paper
to heavy weight, textured cotton rag and the paper
manufacturers now offer an almost bewildering
amount of choice.

web images

Our everyday lives are now so bound up with computer technology that it's hard to see how we could now survive without it. Photography is just one area where working practices have been transformed by computer technology. The ability to send images by email and to have them displayed on a web site is now available to all at a relatively modest cost and the concept of publishing is no longer limited to the printed page.

Photoshop's Save For Web feature found in the File menu can guide you through the process of preparing your images for web display.

Images intended for email and web site display do need to be prepared in a way that makes them as fast to send and download as possible. For these purposes it's not necessary to make the image any larger than about 800 pixels wide or deep and in many cases half this size is enough. The images should be saved as compressed JPEG files with a degree of compression that makes the file size as small as possible without compromising quality too much. It's invariably necessary to apply a degree of unsharp masking once the image has been adjusted for size in order to present a crisp clear image on the screen.

There are numerous web sites that offer keen photographers the facility of having their own portfolio or gallery of images on line for all to see and comment on, very often at no cost. It is rather like belonging to a vast international camera club and, as well as having the satisfaction of displaying your own work, it can also be very instructional to see the work of others and receive their comments and suggestions.

The web has also made it much more possible for those who have ambitions to see their work in print and perhaps to generate some income from their photographs. One of the most practical ways for a photographer to earn reproduction fees from his or her images is with the aid of a photo library. This is effectively an agency that takes a percentage of the fee in exchange for marketing the images. In the past it was necessary to be 'accepted' by a photo library and to do this a submission of several hundred transparencies had to be made.

The system has changed dramatically in recent years and very few photo libraries now deal with transparencies. Digital files are supplied directly to clients, often being down loaded directly from the library's web site. This means there are a considerable number of libraries that are happy to accept relatively small numbers of images from individual photographers without having to go through the process of submission and acceptance. An added advantage is that these images are made available to the library's clients worldwide in a comparatively short space of time.

> **“The web has made it much more possible for those who have ambitions to see their work in print and perhaps to generate income from their photographs”**

This is a page from my own web site showing a selection of my fine art prints

saving and storing

A digital image is in many ways more vulnerable
than one recorded on film, as anyone who has had
a computer crash while working will know, so it's
vital to take special care to ensure that your valuable
images are stored safely at each stage.

The computer's hard drive should only be considered as a temporary haven and ultimately it's best to save images to a CD, DVD or separate external hard drive. In the same way, images on the camera's memory card need to be downloaded as soon as practicable.

With memory cards the camera manufacturer determines the file format and usually with the

higher end models there is a choice. Professional photographers often prefer RAW files because the image is not processed in any way and all of the recorded information remains available after downloading for the photographer to manipulate. RAW files are not compressed which means that a high-resolution image will create a large file and take up a lot of memory space. To produce a print of, for instance, 16 × 12 inches at 300 pixels per

"At the minimum JPEG compression setting you will not see any lack of quality for most subjects"

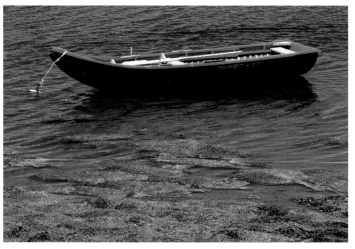

Original image

inch you will need to create a RAW file of about 50 megabytes. This means that if you shoot a lot of pictures in one session you will need to buy high-capacity memory cards, or download the pictures onto a laptop computer, a portable hard disc, a CD or a DVD as you go along.

The most commonly used file format for in-camera memory is JPEG. This is a compressed file so some of the recorded information is discarded when the image is saved. With most cameras you can choose how much compression is applied and at the minimum compression setting you will not see any lack of quality for most subjects. The advantage of JPEG files is that they are much smaller in relation to the image size they will produce and many more can be stored on a memory card.

It is helpful to have a routine procedure that you follow when saving and storing your images. I've developed the habit of storing the complete memory card, as soon as I have access to my computer, on CDs or DVDs (in duplicate). Through learning the hard way I've become a bit of a belt and braces person. While the memory card is still in the card reader I like to do a first edit, downloading and making basic levels adjustments of the images I'm most pleased with. I also store these on duplicate CDs initially but then add key words and transfer them to an exterior hard disc for long-term storage.

Most image editing programs offer a choice of file formats when saving the image. TIFF files are the most commonly used throughout the image industry, because they are compression free and preserve all of the recorded information. This is important if the images are to be used for reproduction or if large, high-quality prints need to be made. But if you intend to make only small en-print sized prints, or they are to be used in emails or on the web, then saving them as a JPEG will save a considerable amount of disc space and you will get very many more onto a CD.

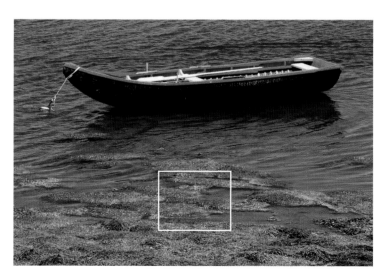

This is the same image as on page 124 showing how maximum JPEG compression will adversely affect image quality. The magnified detail below shows the impact JPEG compression has.

organising and filing

With any form of photograph it's very important to have some sort of filing system because an image you can't find readily is one you might just as well not have taken. The method of storage and filing you decide to use depends upon what you use your pictures for and the quantity you require.

"Much depends upon the thoroughness of the keywording to create a successful system"

If you shoot pictures of your family and friends and only make a hundred or so exposures a year then both storage and filing can be done quite efficiently in an album, both as hard copies and also on line. There are also numerous opportunities available now for storing images on a server free of charge where both you and your friends have access to them.

However, if your output is much greater than this, and you want to be able to find a specific image easily and quickly, then a more sophisticated approach is called for. As a professional photographer it is vital for me to be able to find a requested image as quickly as possible. During the years I shot on film I amassed a considerable number of transparencies that were stored in filing cabinets under various categories. I then simply viewed the appropriate storage sheets on a light box and selected the ones I needed. This was not a very hi tech system but it worked. However, it's a different matter altogether when you have acquired a significant number of digital images.

Photoshop's keywording facility is found in File>File Info

Photoshop's File Browser, found in File>Browse,
enables you to search image files on your hard drive
using keywords as well as file names.

At first I could cope by simply storing my digital images on CDs and filing these with a contact reference sheet, then searching visually as I had done with the transparencies. But this system rapidly became impractical. Most photo libraries now deal only with digital images and they all use a very similar system for storage, filing and searching. The images are stored on a server, effectively a massive hard drive, and filed using keywords that are then used to find specific images. Much depends upon the thoroughness of the keywording to create a successful system. For most of my images I use the location followed by any other relevant factor, such as the name of any prominent buildings, the season, the sky and so on. If you have just a few pictures of a place then a single keyword identifying it is sufficient but if you have dozens of something like Notre Dame, for instance, you could add front, back, interior or night etc, to make the search more specific.

Large capacity external hard drives are relatively inexpensive these days and are probably as safe and secure as any other form of image storage. CDs and DVDs have question marks over their long-term stability and the longevity of transparencies is by no means guaranteed. There are a number of programs, such as Extensis Portfolio, which are designed to store, keyword and search for images in this way. Most of these are quite complex and necessary mainly for those with very large collections of images. However, many of the imaging editing programs offer a simplified facility that is more than adequate for the keen amateur photographer or freelance pro like myself. Photoshop, for example, has a keywording facility found in File>File Info and also in File>Browse and there is a search facility in File>Browse.

Additive Colour: White light is created when red, green and blue light sources of equal brightness are projected onto the same spot. When the red light is switched off cyan is created by the addition of green and blue, the absence of green produces magenta and without blue the result is yellow.

Algorithm: A mathematical formula which determines a series of steps in a process or operation.

Aperture: A hole of variable size which controls the brightness of an image formed by a lens and used in conjunction with the camera's shutter to control the exposure.

Bit: The basic unit with which information is recorded on a computer.

Brightness Range: The difference in brightness between the darkest tone in a scene or image and the lightest.

Burning: The process of giving additional exposure to a specific area of an image.

Byte: The prime unit of digital information.

Calibration: The process of matching the prime source of an image file to its output.

CD-ROM: Compact Disc-Read Only Memory, a basic method of storing digital information commonly used for both music and images.

CMYK: Stands for cyan, magenta, yellow and black and represents the basic ink colours used in printing processes and known as subtractive colour. Cyan, magenta and yellow are the complementary colours to the primary, or additive colours of red, green and blue and when combined with equal density make black. A black ink is used additionally to ensure maximum density.

Colourise: The process by which colour is added to a monochrome image.

Colour Gamut: The colour range which can be displayed or reproduced by a particular device or process.

Colour Saturation: Describes the purity of a hue. The presence of white or black results in a colour being less saturated while the absence creates a fully saturated hue.

Colour Temperature: A means of measuring the colour quality of a light source expressed as degrees Kelvin. Midday sunlight is 5600 degrees K.

Compact Flash: A storage device widely used in digital cameras.

Compression: A means of reducing the file size of an image or other digital information.

D Max: A measurement of the darkest tone which a process or device is capable of displaying or reproducing.

Depth of Field: The area of acceptably sharp focus behind and in front of the point upon which a lens is focused.

Dodging: The process of reducing the exposure on an image in a specific area to make it lighter.

DPI: The number or ink droplets per inch which a printer is capable of producing.

Duotone: A method of using two inks of different hues to reproduce a monochrome image.

Flat Bed Scanner: A scanner designed to create a digital file from an illustration or document using reflected light.

Focal Length: The distance between the optical centre of a lens and the surface of the camera's sensor, which determines the field of view. A short focal length lens gives a wider angle of view than a longer one.

Gamma: A measure of image contrast.

Histogram: A bar graph which shows the tonal range of an image in terms of the number of pixels which each tone possesses.

Interpolation: A method of enlarging an image by artificially increasing the original number of pixels.

JPEG: A method of storing an image which provides varying degrees of compression to reduce the size of the file.

Megapixel: A unit of one million pixels used to describe the resolution of a digital camera.

Noise: Background interference in a digital image which can degrade it. It is more prevalent in poor light, using higher ISO camera settings and when using long exposures and has an appearance and effect similar to that of film grain.

Pixel: The smallest unit of a digital image.

Pixellation: The result of individual pixels becoming visible in an image which can be caused by over enlargement or when extensive manipulation has been applied.

Polarising Filter: A filter used on a camera lens to eliminate or reduce light which is being reflected from a non metallic surface.

Posterisation: The effect of rendering an image as a small series of visible tonal steps instead of a smooth graduation.

RGB: Stands for red, green and blue, the primary colours which make up white light.

TIFF: The most widely used file format used for the storage of digital images.

Unsharp Masking: The process of making an image appear sharper by increasing edge contrast.